Collins **Learn to Paint**

country flowers
in watercolour

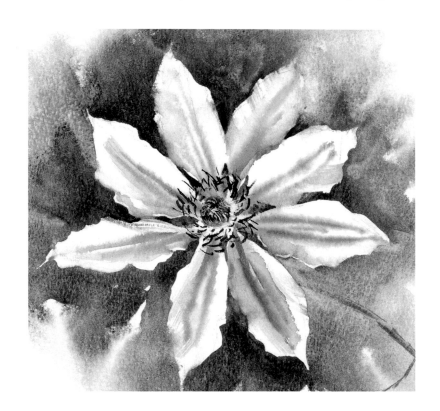

Ann Blockley

Collins

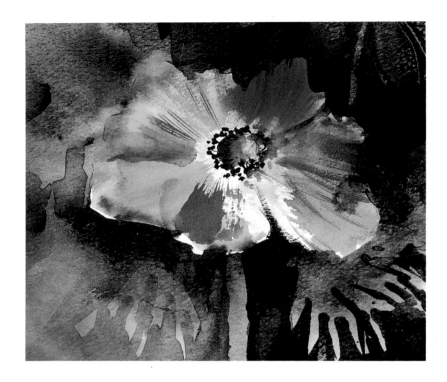

First published in 2003 by
Collins, an imprint of
HarperCollinsPublishers
77–85 Fulham Palace Road
Hammersmith
London W6 8JB

The Collins website address is
www.collins.co.uk

Collins is a registered trademark of HarperCollins Publishers Limited

11 10 09 08
6 5 4 3 2 1
© Ann Blockley 2003

Designed and edited by Flicka Lister
Photography by Richard Palmer

A catalogue record for this book is available from the British Library

ISBN 978 0 00 729 720 7

Colour reproduction by Colourscan, Singapore
Printed and bound by Printing Express, Hong Kong

Previous page: **Clematis** 20 x 17 cm (8 x 7 in)
This page: **Anemone** 23 x 23 cm (9 x 9 in)
Opposite: **Lilac** 17 x 17 cm (7 x 7 in)

Contents

Portrait of an Artist

Ann Blockley was born in Lancashire, where she spent the early years of her life. She moved with her family to the Cotswolds in 1975 when her late father, the painter G John Blockley, opened a gallery in Stow-on-the-Wold.

As a child, Ann was constantly painting and drawing but also enjoyed writing. After leaving school, she studied design and illustration at Gloucestershire College of Art and Design, and later at Brighton Polytechnic. After graduating with a BA

◀ Ann Blockley in her cottage garden with her dog, Mole.

Honours Degree in Illustration, Ann launched straight into a successful and varied career as a freelance illustrator, working on many commissions for well-known companies. These included designs for greeting cards, tableware and tapestries, illustrations for educational and children's books, images for packaging on everything from chocolate wrappers to shampoo bottles, and even a set of postage stamp designs for the Royal Mail.

Countryside inspiration

Ann's style of painting was highly detailed and decorative for her commercial work but she was developing another, quite different and more personal style of using watercolour. Subjects for her own paintings were taken from the woods and fields surrounding the country cottage she still lives in with her husband and two children, and her paintings began to feature the poultry and pigs the family reared and the flowers Ann grew around the cottage.

Ann's father, who had written many painting books including *Learn to Paint Pastels* for HarperCollins, suggested that she too might write for them. The idea for a book about painting the countryside emerged and the result was Ann's first *Learn to Paint* book: *Learn to Paint the Countryside*. Since then she has written five books including *Flower Painting Through the Seasons* and has made a video with the same title to demonstrate her painting ideas and unorthodox approach to watercolour.

Ann's career as a painter has blossomed and she has exhibited widely in many solo exhibitions, with buyers from all over the world collecting her work. She is a regular contributor to *Leisure Painter* magazine and also enjoys teaching, sharing her techniques and passion for painting country flowers with the wide range of students who visit the workshops that she and her husband run. Much of Ann's time is spent walking through the countryside and visiting local gardens or

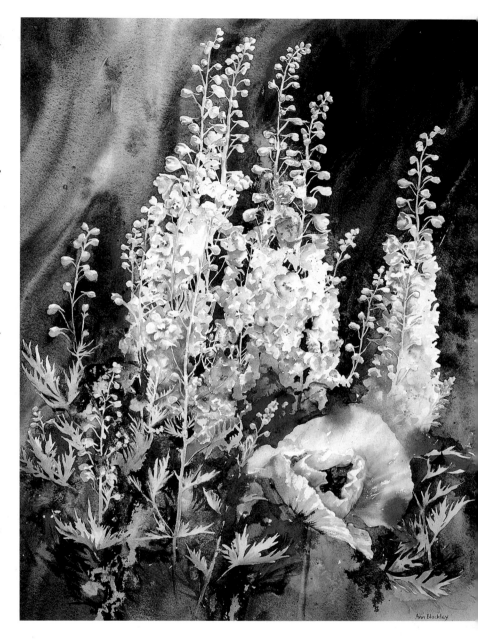

▲ **Delphiniums and Poppy**
70 × 56 cm (28 × 22 in)

country markets to find new subjects and sources of inspiration to share with her pupils. The aim of her workshops is not only to teach painting techniques but also to open her students' eyes to painting possibilities and help them to look at simple country subjects with a painterly eye. *Learn to Paint Country Flowers in Watercolour* continues this theme.

Introduction

▶ I use my sketches and photographs I have taken as reference material, but also work directly from nature. Be prepared to use a little imagination when painting backgrounds, to create the effect of the outdoors.

Flower painting is a magical and evocative subject that is accessible to everyone. The title of this book – *Country Flowers in Watercolour* – was chosen to include not only the wild flowers of the countryside but also traditional cottage garden flowers. These subjects evoke an air of romance and atmosphere which is an aspect I hope to encourage you to explore.

Watercolour can be subtle or vibrant, simple or complex. You can apply it with traditional juicy washes, or play around with a variety of exciting textures and brushstrokes. The following pages show you how to explore these techniques for yourself.

Do spend plenty of time practising the basic washes – these are the building blocks of all watercolour painting. A flowing wash may not be easy at first but perfection is not a prerequisite for an interesting and expressive painting. You will achieve far more by being relaxed, enjoying yourself and accepting that mistakes may occur, than by being worried and timid with the paint.

The emphasis of the book is on loose, painterly work and not detailed, botanical illustration. I want to encourage you to look at flowers in new ways and to develop your own creativity using watercolour. This is a wonderful choice of medium for painting flowers – its translucency can capture the very essence of delicate petals.

At the end of the book, the demonstration section takes you through complete paintings step-by-step to help you to understand the planning process. I hope that, after studying these carefully, you will enjoy applying the principles to your own painting ideas.

▶ **Lavatera**
30 × 23 cm (12 × 9 in)

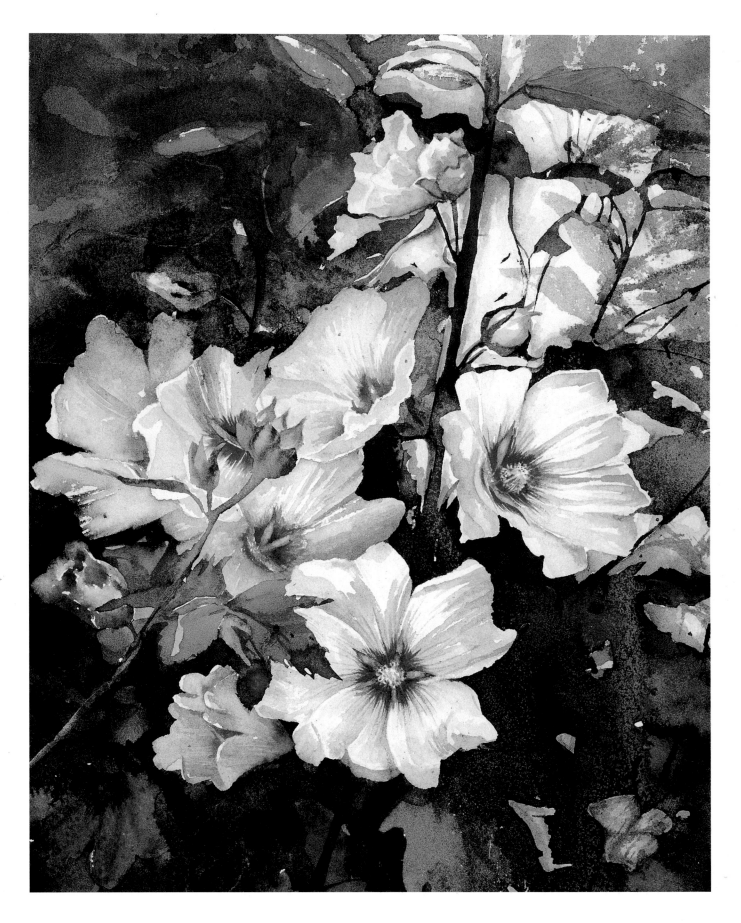

Materials and Equipment

When learning to paint, very few materials are required. A palette and a brush, some paper, water and a few colours are all you really need to get started. The less equipment you have to juggle with, the more you will be able to concentrate on getting to grips with new techniques.

As your skills and confidence grow, you can experiment with a wider variety of colours, paper surfaces and different sizes and shapes of brush. However, it is worth remembering that time and money spent purchasing new materials is no substitute for plenty of practice!

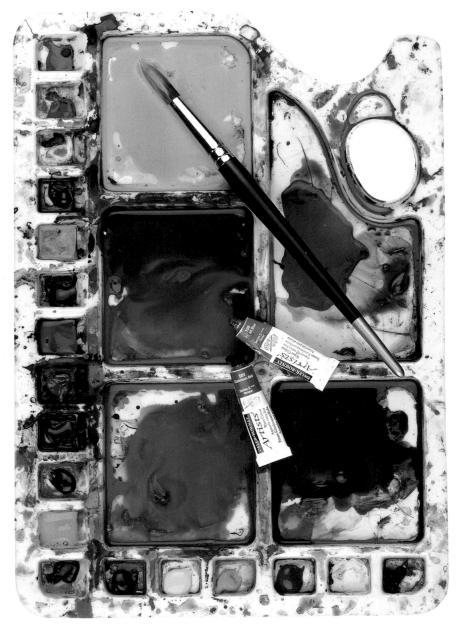

◄ Your palette will reflect your painting style and personality. Mine is a bit disorganised but at least it looks interesting! Choose a large palette with separate compartments for squeezing on paint and mixing your colours.

Brushes

The brush is your main painting tool and it needs to hold plenty of paint, keep a sharp point or edge and be sensitive to a range of movements. All these requirements are a tall order for the old hoghair brushes found in attics or the ones borrowed from your children's paintbox!

Sable is traditionally the favourite choice for watercolour brushes. These are wonderful to use but they are expensive. I find that art brushes made from a blend of synthetic fibres and sable are more economical, perform effectively and actually last longer.

The most important brush for my style of work is one that is suitable for painting large background washes. I use either a flat brush, at least 2.5cm (1 in) wide , or a round brush, at least size 14. The point of a decent large round brush will also allow you to paint details far better than a cheaper, fluffy-ended small brush.

I like the variety of brushstrokes I can make from combining both flat and round brushes in my paintings. A crisp flat brush allows you to make broad strokes and chunky marks, as well as sharp lines with its straight-edged tip. Tiny brushes encourage fiddly work but you will need one smallish brush to tackle compact shapes and subjects.

Paper

All the watercolours in this book were painted on either Waterford or Bockingford 140 lb (300 gsm) watercolour paper. I use a Not surface which allows you to put in detail and the paint to flow. Waterford is slightly creamy in colour and adapts itself to many methods, being especially suitable if using masking fluid. Bockingford is a less expensive paper. It has a very white surface that is useful for clean, bright subjects. Paint often granulates well on this surface, creating an interesting grainy texture. It also lifts easily which may or

▲ Good brushes are vital. Shown here are (from the left to right): 2.5 cm (1 in) flat, size 14 round, 6 mm (1/4 inch) angled, and a size 4 round. The angled brush isn't essential but is great fun for painting into corners and up to edges. The paper is Waterford (on top) and Bockingford (underneath).

may not be an advantage, depending on your plans! Bockingford is slightly softer than Waterford, which means greater care is needed when using masking fluid on the surface (see pages 19–21).

There are many other types of paper to experiment with. Rough surfaces are particularly suited to textured, loose work, while HP (Hot Pressed) paper has a smooth finish that lends itself to a more detailed, botanical style. Paper also come in different weights. Personally, I dislike very heavy papers, which feel as if I am working on cardboard. However, the wet paint used in this book would cockle a 90 lb paper dramatically – such paper is only suitable for more detailed, dry work.

I buy paper in sheets that can be cut down to whatever shape or size suits my subject. I do not stretch it, preferring to begin work on a freshly chosen format. The act of stretching paper can easily become an impediment to spontaneous work. It gives the blank sheet of paper even more importance and thus adds to the fear of starting work. Any slight cockling can be flattened during the mounting and framing of the final picture.

Watercolour paint

It is well worth investing in artists' quality paint. The students' colours are made with cheaper pigments and are less vibrant, more muddy, and lift too easily when building layers. This can be very dispiriting at the stage when you most need encouragement. My style of work uses a quantity of fresh, moist paint that you can only mix easily from tubes. Pans of paint release only enough pigment for small areas and details.

Choosing colours is very personal and every artist will recommend a different palette. The colours most frequently used in this book are shown on this page. The very nature of flowers means that you may not cover every eventuality with this basic palette – or colour match with botanical accuracy – but it should be versatile enough to meet most of your needs and you can add extra colours as your work progresses.

Basic Palette

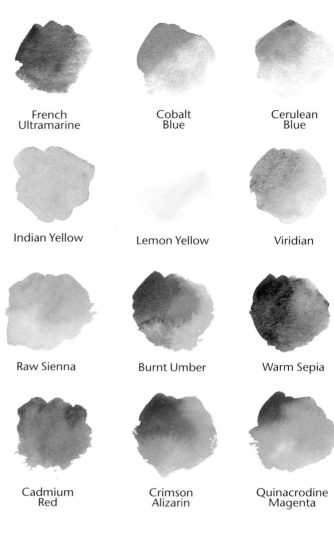

French Ultramarine Cobalt Blue Cerulean Blue

Indian Yellow Lemon Yellow Viridian

Raw Sienna Burnt Umber Warm Sepia

Cadmium Red Crimson Alizarin Quinacrodine Magenta

Extra Colours

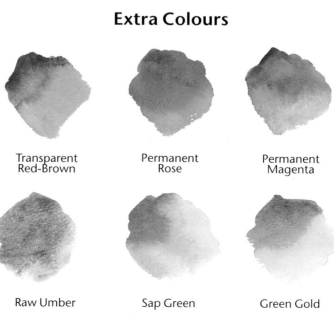

Transparent Red-Brown Permanent Rose Permanent Magenta

Raw Umber Sap Green Green Gold

Other equipment

A large sturdy pot for water is vital. In fact, I keep two pots beside me – plus a large plastic bottle of clean water. I've found that having these at hand ensures that I can replace dirty water quickly without any inconvenient, even fatal, interruptions during washes. Clean water is essential for fresh watercolours.

You will need some form of support for your paper. I have a selection of plywood boards chopped into different sizes to suit my different picture formats. With these it is easy to work flat or, when applying washes, tilt the board to let the paint flow downwards. I don't work on an easel except for occasional outdoor work.

You will need a soft B pencil and a putty eraser for drawing. I use masking fluid quite frequently when I work, applying it with a rubber shaper or blender. These are more versatile than brushes and masking fluid is easily removed after use. A pen and nib or ruling pen can be used to apply the fluid in fine lines, giving endless opportunities for texture-making and having fun.

A selection of other items, such as salt, a palette knife, sponges, paper towels and a scalpel will also come in handy.

◄ Assemble everything you may need before starting work. There is nothing worse than interrupting a watercolour at a crucial stage to search for a mislaid tool.

Watercolour Techniques

The joy of watercolour is its freshness, translucency and vitality. In order to maintain these features, it is essential to master basic washes. As I said earlier, they are the building blocks of the medium.

A wash is a series of overlapping brushstrokes that covers any area of paper, large or small. Washes do not have to be perfect or devoid of irregularities, but they should be relaxed and flowing. Try to paint them as boldly as you can. Also, since watercolour becomes paler when it is dry, make sure the colour mixes for your washes are sufficiently strong. It is possible to build up watercolour in stages but each successive layer of paint becomes less transparent and therefore less vibrant. Aim to do as little work as you can to achieve the greatest effect and make every single brushstroke that you make count.

A basic wash

To paint a basic wash, tilt your board and let gravity help the watercolour flow and gather in a pool along the bottom edge of each brushstroke. This will subsequently merge into the following slightly-overlapping stroke. Your brush should always be full, so reload it as required. Repeat the process until you have covered your chosen area of paper, then lay it flat to dry.

Never be tempted to rework a wash, as you may spoil it. Working on damp paper helps paint to blend but remember that the dampness will dilute the paint and make it paler when dry.

To start, try painting a wash using only one colour to cover up as flat an area as possible. You rarely need a flawless, plain wash but it is useful to practise keeping your paint and brushstrokes consistent.

▲ Squeeze a generous blob of pigment into your palette and dilute it with a brush to a milky consistency (less watery than skimmed milk, but not as thick as cream!)

Your paint needs to flow on the paper but still be under control. Always make sure you mix enough to complete a wash, and keep your brush loaded but not dripping.

◄ When applying a wash, brushstrokes can go in a parallel, horizontal pattern, as shown here, or in any direction to suit your picture. The important factor is to let the gathered paint merge into the next brushstroke without further interference or blending.

Variegated and graded washes

It is more common in a finished painting to need washes that vary in colour or tone. These are called 'variegated' and 'graded' washes. The changes may be subtle or dramatic, occurring in large backgrounds or small shapes, such as leaves or petals. For a variegated wash, you change colours when you reload your brush, allowing the new pigment to merge with the previous one when you apply your next brushstroke. When painting a graded wash, the brush is replenished with water instead of paint, so the wash turns progressively paler as you work.

► When you paint a variegated wash, always dilute all the colours you need in advance, renewing your water for each separate pigment. Let each colour touch and blend with the next one, using a minimum of brushwork.

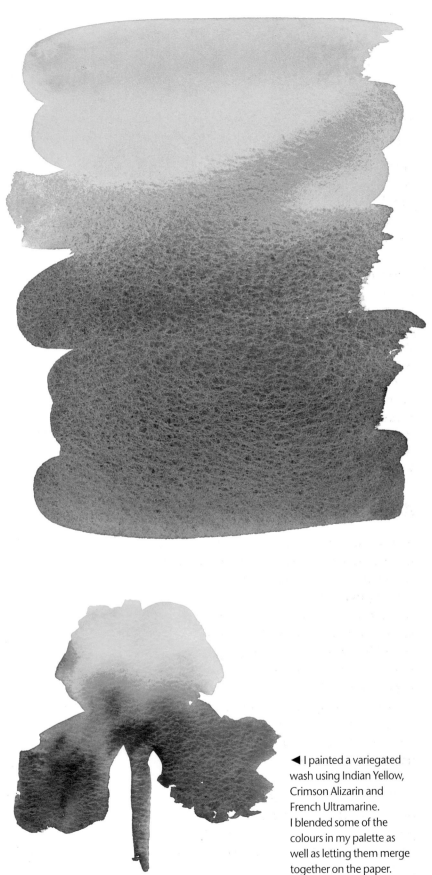

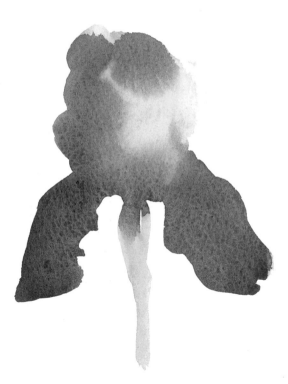

▲ You often need to paint a wash within a specific shape. In this iris, I started on the two dark lower petals, working upwards and adding water towards the top to grade it into a paler area. Then I added the stalk by painting down from the still-wet base.

◄ I painted a variegated wash using Indian Yellow, Crimson Alizarin and French Ultramarine. I blended some of the colours in my palette as well as letting them merge together on the paper.

Wet-into-wet

Wet-into-wet washes form the basis of most background work and, despite their sometimes frustrating idiosyncrasies, can be wonderfully atmospheric and one of the delights of watercolour. This technique is an extension of the variegated wash. When you lay a wash and immediately add further paint to it, you are working 'wet-into-wet'.

Timing the addition of the new paint is of paramount importance. As in all washes, the paint should be of an equal consistency and wetness to ensure a soft, gentle merging of colour. If you touch a new colour into the middle of a wet wash with your brush, the new pigment will react in different ways according to its degree of wetness. It will usually spread further than you anticipate, so beware of buttercups growing into sunflowers! Only practice and experience can teach you this kind of information – there are no magic formulas.

Soft edges

Painting on wet or damp paper is another type of wet-into-wet work, and this results in soft, hazy edges. If you are not confident enough to try this slightly unpredictable approach, a similar effect can be achieved by painting onto dry paper or a dry wash and running a clean wet brush along the edge to soften it. This is a useful technique for shading and is also the method used in negative painting.

a A wash painted onto damp paper creates blurred edges.
b A 'cauliflower' occurs when wet paint pushes into drying paint.
c Colours blend evenly when they share the same consistency.
d A crisp white shape is left within a wash.
e Crisp edges are retained when paint is applied to dry paper.
f A cauliflower has been developed into a leaf.

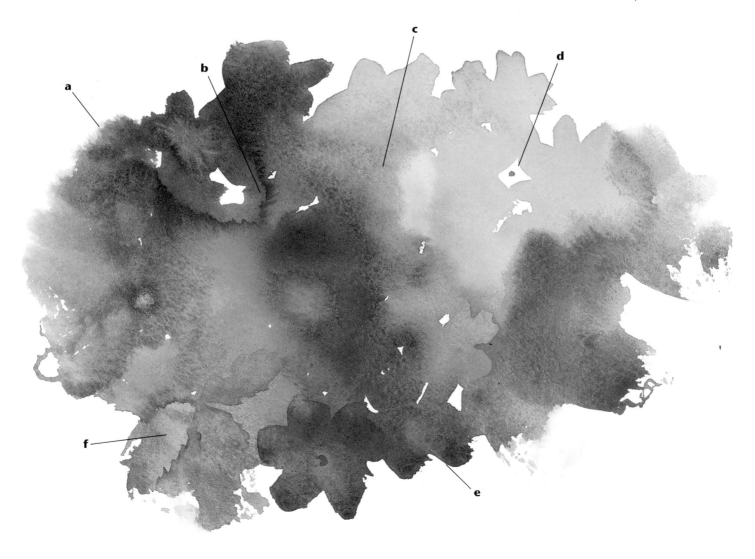

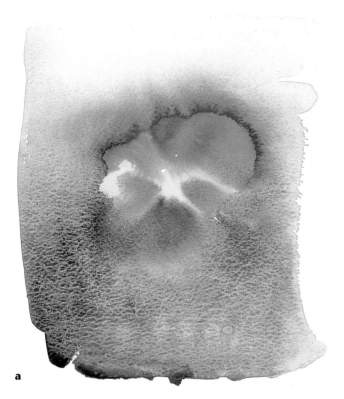

a

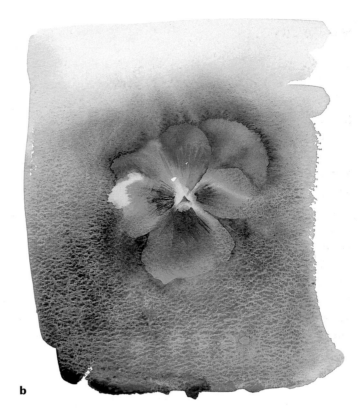

b

What can go wrong

Backruns, watermarks, cabbages and cauliflowers! These are all names for those ragged-edged marks that mysteriously appear within washes. There is no evil force at work – this simply occurs when wet paint is brushed or runs into a damp or drying wash.

To avoid this happening, paint applied on top of or next to a wash should always be of equal consistency or dryness. If the shine has disappeared from any part of a wash, it is no longer safe and must be left to dry. This is the chief reason why it is dangerous to attempt to improve an uneven wash.

Backruns often occur around the edge of a painting where gathered paint runs back into the drying picture. This can easily be avoided by soaking up any excess watercolour from the edge with a damp brush. It is well worth playing and creating these cauliflowers deliberately. Actually seeing the process happen helps your understanding of it. You can learn a great deal from watching paint dry!

a Using uneven strengths of paint has caused a cauliflower to appear in this wash.
b I didn't attempt to remove the cauliflower, but made a feature of it by allowing the wash to dry, then adding edges and details to coax it into the pansy shape.

Before you begin a large wash, loosen up by having a practice run on spare paper.

Happy accidents

The good news is that, once you know how to control them, cauliflowers will no longer be a subject of dread and can become a technique to create on purpose. The irregular edge values have a special quality of their own with which to build wonderful marbled background textures and suggest the edges of leaves, petals and flower centres. In the right place, this characteristic of watercolour really can become an interesting feature of your paintings.

a

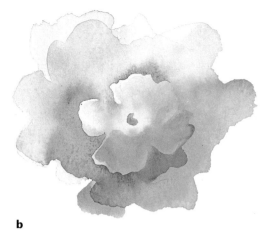

b

c

d

a I painted a wet-into-wet wash, then touched the pink with a hint of yellow to describe the soft flower centre. This was left to dry.
b I drew a pencil outline of the polyanthus on top of the dry wash, then painted a darker colour around it to create a negative flower shape. I added shading and detail to the petals.
c I left a crisp white petal shape within this wash to make the flower stand out more than in example **a**.
d As before, I added darker background colour to define the petals, then painted strong patterns around the middle to describe the centre.

Wet-on-dry

Wet-on-dry does not have the truly magical quality of wet-into-wet but it is far more controllable and can be vibrant and exciting. To do it, you paint on top of a totally dry wash. You can build up crisp layers of colour or simply add detail or brushwork to give shading and depth where required. If the first wash is even slightly damp, you will disturb it and the result will be muddy. It must be totally dry to remain clean and sharp.

Negative and positive painting

Watercolour is a translucent medium and therefore it is not possible to add pale colours on top of darker tones. Instead, you need to plan ahead and work from light to dark. Positive painting is where dark tones are added in a specific shape on top of a paler base wash. It is a form of wet-on-dry work. Negative painting is when a shape is defined or pulled out of a light-coloured wash by painting darker tones around the whole or part of the chosen area.

The new layer of darker colour should not be just a line or halo around the negative shape but should be blended with water until it gradually fades into the first wash. This is a particularly useful technique for making features emerge out of a wash – for example, leaves and stems can be made to appear out of backgrounds, or stamens and centres can be conjured out of flowers. Some subjects will be lit in such a way that they are made up of a more complicated combination of positive and negative patterns. Try to simplify these wherever possible.

Reserving white paper

Because watercolour is translucent, it seems a shame to cover it with opaque white paint. The freshest, liveliest results occur when the white of the paper is reserved. When you paint around a white shape, start at its edge and work outwards into the background. This way, the most intense colour is retained at the perimeter of your subject and the image stays crisp and neat.

When the shape you have to paint around is complex or large, it helps to dampen the area where you begin the wash. This will ensure you have soft marks to link up with when you complete your wash circuit, instead of a problematical hard edge. The advantage of painting around a shape over using masking fluid (see page 19) is that edges can be softened where required before the background dries.

Sparkling paper

Washes don't have to cover every centimetre of paper evenly. Sprinkles and patches of white paper left within a wash can really make it sparkle. I try to keep such marks and gaps meaningful. They can hint at the spaces between stalks and branches or evoke snippets and edges of petals and leaves that catch the light. They may simply be part of an appropriate background texture.

▼ Blossom
Crisp sharp edges and chunks of white keep this sketch full of vitality. The buds were created by leaving simple patches of paper – I added no further detail. Water was then dropped wet-into-wet amongst the background colours to create cloudy marks that contrast with the clean edges of the blossom.

Lifting colour

Watercolour is not waterproof. This means that colours can be lifted or blotted off to make highlights, pale shapes and soft details. Paint can be lifted with a damp brush or dabbed away with a sponge or paper towel. The results depend on how wet the paper is and how firmly you apply pressure.

Edge values

If paint is removed when it is very wet, the wash may flood back into the shape. However, if the paint is dry, you can re-dampen the chosen area and then blot the colour off. This generally leaves a harder edge than lifting in the first stage. Results also depend on the pigment used, since some colours stain more than others.

a The crisp edges of this snowdrop were made by painting around the flower. The edge of the background shimmers where thick paint was dragged across dry paper. The stalk was lifted out with firm pressure from a moist brush.

b This snowdrop was painted around as before but I blurred some of the edges with a damp brush while the background was still wet.

c I lifted this snowdrop out of still-wet paint.

d I lifted the soft petals out of the damp background wash and left it to dry, then made crisp white highlights along some edges with the damp point of a brush and firmly blotted them with paper towel.

e A range of edge values is vital to create depth and variety. Notice how hard edges come forward and soft edges retreat.

Lifting colour is a useful technique for creating soft background flowers and leaves.

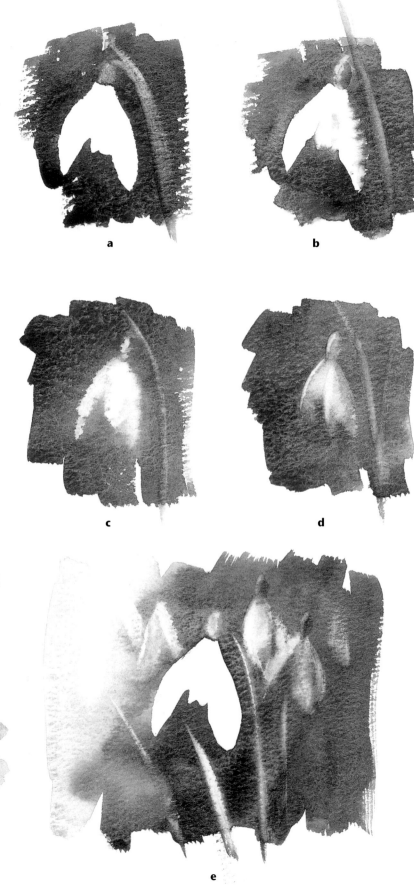

a

b

c

d

e

Using Masking Fluid

a

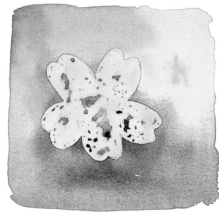

b

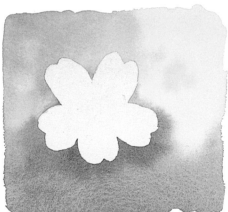

c

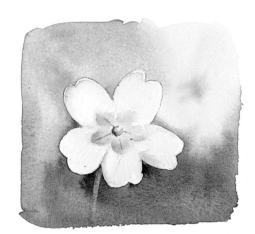

d

a I drew a simple flower shape and, using a shaper, carefully filled it in with masking fluid. I left this to dry completely.

b I applied a wet-into-wet wash onto the background, painting over the edges of the masking fluid and making sure that no white gaps were left to spoil the shape.

c Once the wash was dry, I peeled off the masking fluid to leave a crisp, white shape. At this stage, hard edges can be softened with a damp brush.

d Finally, I filled in the primrose with paint. Using masking fluid gives crisp-edged shapes that can become focal points in a finished painting.

asking fluid is a liquid that can be painted onto specific areas of paper to protect them from paint. In subsequent stages, the dry mask can be peeled away to reveal white paper ready for further paintwork.

The biggest advantage of this method is that complex shapes can be preserved in advance, allowing more time for the nail-biting process of applying backgrounds. Loose, broad washes or experimental techniques can be used straight over the masked areas, without the problem of having difficult shapes to paint round.

Although the preserved white paper left by the masking fluid makes this method ideal for white or pale flowers, it is also invaluable for retaining the freshness and life of subjects which are a different colour or darker than the background. Masking fluid can be white, yellow or blue. I have chosen yellow in this book for visual clarity. I find blue very distracting when making decisions about tone or colour in later stages of a painting.

You can also use masking fluid on top of a totally dry wash. This is a useful method for small areas and details such as leaves, stems, stamens or small background flowers, as an alternative to negative painting. However, if you have used a non-staining pigment, be aware that some of the colour may lift off when you remove the masking fluid.

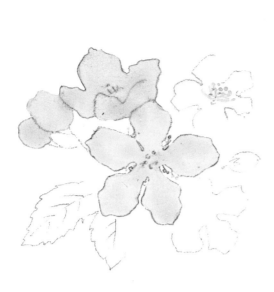

▲ I drew the blossom and buds with minimum detail as masking fluid can lift off pencil when it is removed.

I masked shapes I wanted to focus on, painting any overlapping areas as one abstract shape.

▲ I left a few hard-edged marks in the background to help balance the crisp flowers with the soft wash. I also included some flower colour in the background. When this was dry, I peeled off the masking fluid.

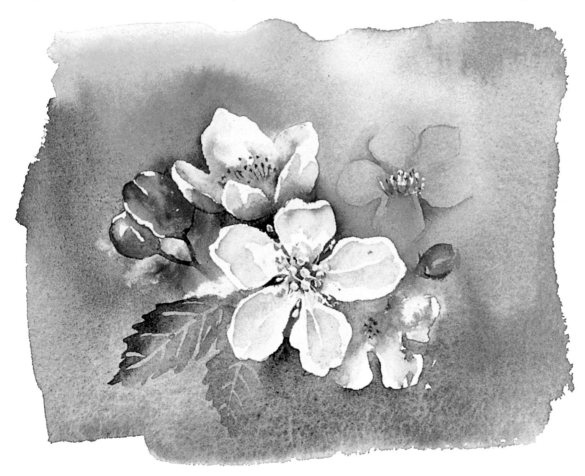

◄ The aim of this stage was to fill in and integrate the flowers with the background. The use of occasional dark colour helps them to sit comfortably within the wash. The crisp edges of the negative background flowers and positive leaf shapes also help balance the whole picture.

Seven golden rules for masking

Common criticisms of masking fluid are that the paper tears or the paint seeps through. However, I must say that I find that any problems my students have are always caused by not adhering rigidly to the following rules:

1 Some papers are too soft for masking fluid. Paper must be tested by painting an area of at least 5 cm (2 in). It must be left to dry thoroughly before removal.

2 Do not dilute masking fluid. If it is too solid to pour, it should be replaced.

3 Stir rather than shake your bottles before use, as any bubbles pop when dry and create holes for the paint to sneak through.

4 Do not apply masking fluid too sparingly or thickly – an even coat is required. Make sure that you do not leave any streaky gaps or holes.

5 It is absolutely essential that the masking fluid is dry before applying paint. Follow this rule to avoid ruined brushes, torn paper and seepage.

6 Washes must be similarly dry to avoid smudging and spoilt paper. 'Dry' means bone dry, right through from the back to the front of the paper and not just the surface.

7 To remove masking fluid, first loosen an edge with your finger, then peel it off carefully. Use a putty rubber to remove any awkward spots. If the mask sticks or the paper starts to tear, it will be undoubtedly be due to dampness.

If you follow these rules closely, you should find that masking fluid is an invaluable tool. Its purpose is to help make your painting easier. However, if you find that it does not suit you, simply paint around your subject in the traditional way. The choice is yours.

Use a hairdryer to speed up the drying time of masking fluid. Dry the back as well as the front of the paper.

▶ Masking fluid can be applied with various tools. I use a rubber shaper or blender with a flat-angled edge for large areas. The sharp tip can get into corners or draw details, dots and flowing lines. A ruling pen or pen and nib is useful for finer lines. The edge of a palette knife can also create straight, crisp linear marks and its tip can be used to splatter dots.

Making Marks

You can make marks in many different ways using brushes, pens, sticks, cardboard or sponge – anything, in fact, that can be dipped into paint and transferred onto paper. The marks you make can be small, delicate and applied individually, or thick, dark and repeated to build up heavy textures. Marks can be made onto damp, wet or dry white paper, or on top of washes. You can draw dots and squiggles, solid or broken marks, or curved, straight or twisting lines. Experiment and practise thinking all the time what each mark reminds you of and how it might be used in a painting.

Brushwork

Brushes are the most important mark-making tools. These can be laden with paint for juicy washes, or kept thirsty for drier, broken work. You can vary the pressure to create thin or thick lines. In flower painting, leaves, petals and grasses often have tapering shapes. Use the pointed tip of a round brush for narrow marks, pressing the body of the brush down for broader shapes. The point can also be used to stipple dots.

Alternatively, the hairs can be splayed with your fingers to form a fan and dragged lightly to make feathery marks. You can make a wide variety of chunky strokes with a flat brush, as well as using its straight edge for short lines.

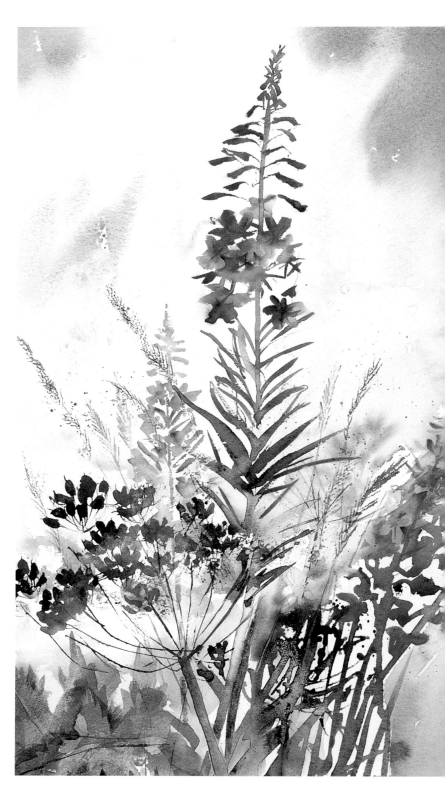

▶ **Willowherb**
43 × 25 cm (17 × 10 in)
This painting was a workshop demonstration to show students a variety of marks and brushstrokes within one picture. I used bent cardboard to paint the hogweed umbels, the end of a flat brush to stipple the grasses, and general brushwork for the willowherb.

22

► Pasque flower

I used the tip of a brush to paint these ferny leaves, flicking the paint in quick, delicate movements.
I used my angled brush for the broader, pointed petals, varying the pressure and twisting the brush to alter the shapes as needed.

▲ Hydrangea

I painted some loose texture with a natural sponge and added the petals around this with curved brushstrokes.
I then used a small brush to turn some of the abstract texture into little florets.

► Thistle

The flower head was painted with light strokes of sparse, dryish pigment. The paint for the base was thicker but still moist, which allowed me to scrape sharp, pale marks out of it with a scalpel. The angular leaves and stalks were painted with the edge of a loaded palette knife.

► Grass

I sponged on some texture, then loosened the effect by splattering more colour on with the tip of a palette knife.
I then dragged the edge of the knife through the damp paint to pull some of it into sharp lines. The stalk and leaves were added with undulating brushstrokes.

23

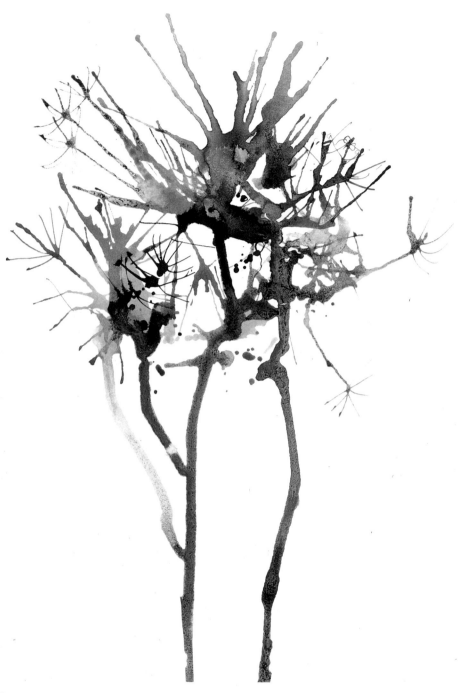

▲ Hedgerow Tangle
25 × 17 cm (10 × 7 in)
I blew pools of paint, coaxing it to shoot off in suitable directions. The little blobs of paint that gathered at the end of each dribble were dragged with a sharp point into delicate lines and tendrils.

When working into textures, do not tidy up too much or you will spoil the abstract qualities.

Having fun with texture

All watercolour painting should be fun, but I find the more unorthodox and experimental techniques especially enjoyable. Since these methods encourage us to be totally uninhibited and free with our paint, the results can be a refreshing extension of more conventional work. I do, however, use them with a degree of restraint – the technique must be wholly appropriate to the subject, since combining an excess of different effects can be like having too many flavours in the cooking pot!

Dribbles

Blowing paint around paper and allowing it to dribble freely can create fascinating marks and lines. Try dripping small pools of dilute paint onto the paper and then gently blowing it where required. The paint often divides into ever-decreasing lines. If a greater degree of control is needed, direct the paint by blowing it through a drinking straw. You can also tilt your paper, allowing any liquid paint to dribble downwards to make meandering stalks and wintry twigs.

Salt

One kitchen ingredient I use in my paintings is salt. When it is sprinkled into damp paint, it absorbs the pigment to leave pale 'snowflake' marks. The result is unpredictable, but usually very interesting. It varies according to the type of salt used and the wetness of the paint. Salt can be used to make speckled leaves, spotty petals, textured flowers such as sedums, cow parsley or lilac, or simply within a wintry background.

Clingfilm

Placing clingfilm on top of a wet wash can help you to achieve some really wonderful geometric patterns within paint that has been applied to the paper. The clingfilm can be crumpled or stretched into linear folds to create different marks to suit your subject.

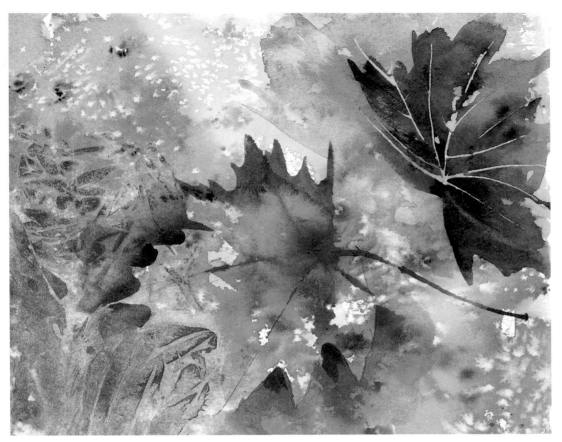

For grassy meadow backgrounds, I might use vertical marks, while for the kaleidoscopic colours of autumn leaves, random patterns are usually suitable. Large or small pieces of clingfilm can be used over all or part of a wash. It must be left to dry completely, which can take hours. A hairdryer cannot be used, as this blows the clingfilm away and, if removed too soon, the textures fade or disappear. When the paint is completely dry, the clingfilm can be discarded and the markings worked into – or left, if so desired.

Washing out

This is a method I use to achieve a range of edge values. I paint a wash and then, when it has dried in places, carefully drip or pour water onto parts of it. The timing is critical. The paint must be partly dried with some damp bits remaining. The wet paint rinses away to leave cloudy marks but the dry areas, which are usually around edges, stay crisp and sharp.

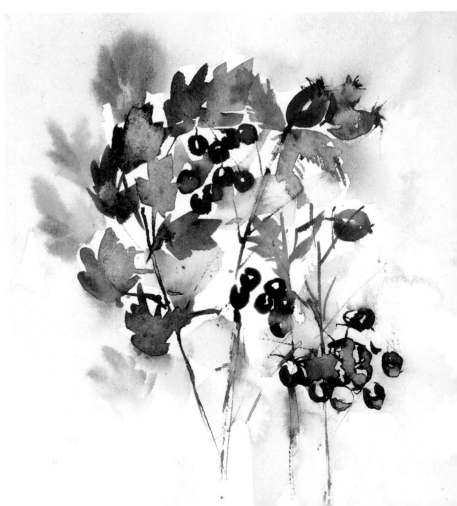

Using Colour

▼ **Pansy**
35 × 30 cm (14 × 12 in)
Washes of Indian Yellow,
Crimson Alizarin and
French Ultramarine were
allowed to flood together
wet-into-wet on the paper.

In botanical painting, you need to mimic nature with your paint colours as closely as possible. With my style of painting, colour matching is not so vital. It is more relevant to create moods and for the pigments to remain clear and fresh. As artists, we are not restricted to using the colours we see. Our aim is to make a statement, to excite or calm. We can be innovative and imaginative, evoking a temperature or a time of day through appropriate use of warm or cool colours and the juxtaposition of different hues.

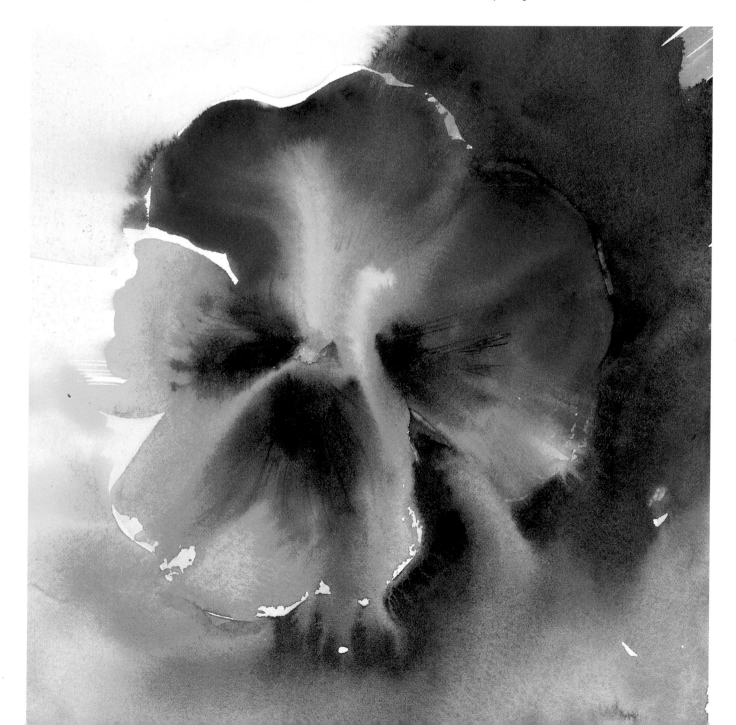

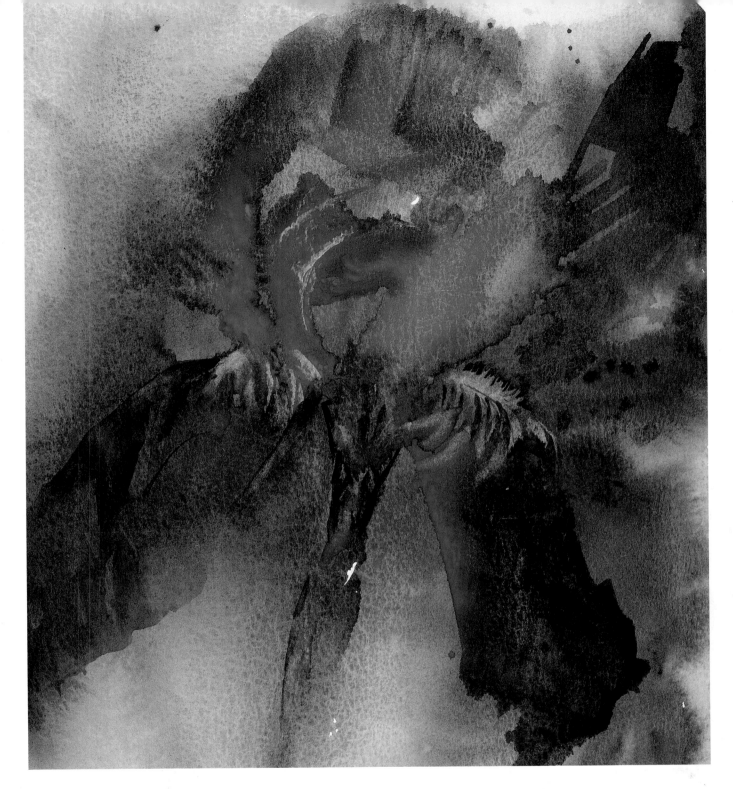

Let your colours flow

When you are painting, try to let your colours flow from one part of your picture to the next. Be prepared to lose boundaries, soften edges and merge colours to unify separate elements. Children use colour within outlines, using preconceived ideas of what hue the subject should be. We can be subtler than this. A green stalk could be allowed to stream into the pink of a flower. Petals can emerge out of a background colour. Background tints may occur within flowers, especially where petals are transparent. Use your palette, but don't forget to use your imagination, too!

▲ **Iris**
33 × 25 cm (13 × 10 in)
This painting isn't concerned with the complicated iris structure but rather with variations and nuances of colour.

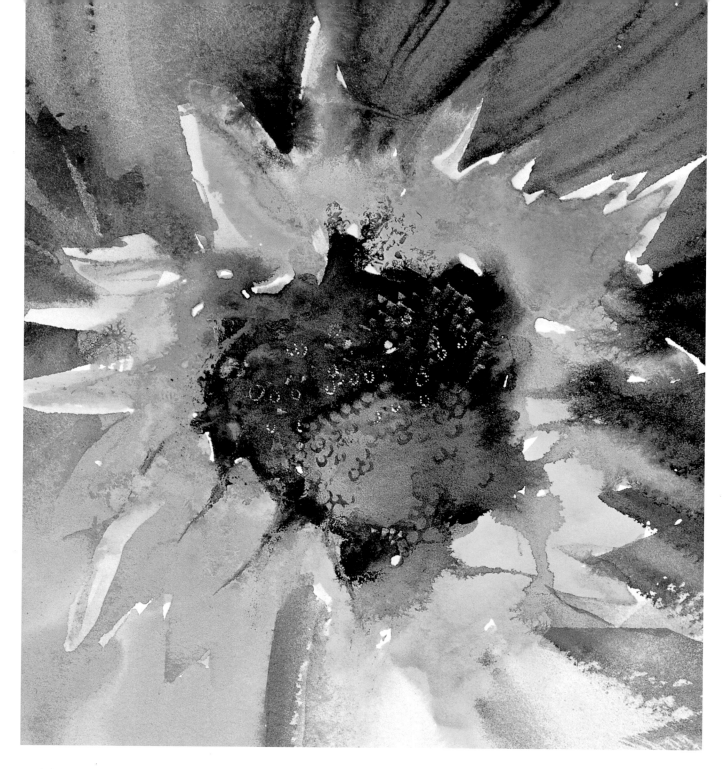

▲ Sunflower

20 × 15 cm (8 × 6 in)
Shading yellows is quite difficult because the colour easily becomes muddy. Here I have just allowed the darker colours to blend freely with the yellow to create a very loose idea of light and shade.

Light

Warm sunshine makes flowers glow but the same flowers at twilight take on cooler tones. Light is also reflected off surrounding flowers and leaves or bits of background and these all affect the colour of a subject. A pink flower may also contain hints of blue, green and yellow if these hues are present elsewhere. Repeating colours in this way helps to give a painting variety and unity and leads the eye around the picture.

The appearance of the colour also depends on the way in which it is presented. For example, reds will seem brighter against a contrasting green background than they will next to a related colour such as brown. The greater the total contrast between adjacent

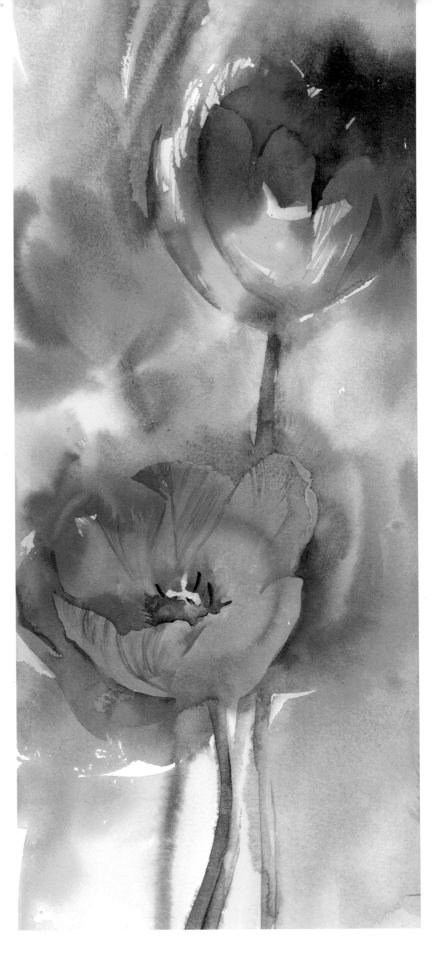

► **Tulips**
48 × 20 cm (19 × 8 in)
I wanted to create a light, fresh, spring-like atmosphere with clean, clear colours. I used green to complement the reds and allowed each area of wash to flow into the next, retaining many soft edges.

colours, the more vibrant they will appear. Contrast is the key for bright, exciting painting using strong lights and darks or complementary colours. A quieter, harmonious effect is achieved where colours of a similar type or tone are used.

Avoiding mud

A muddy watercolour is one where the colours seem dull and tired, having lost their translucency. This does not mean your painting has to be garish. On the contrary, it may be composed of subdued, subtle colours and will remain fresh-looking if the paint is applied correctly.

It is important to remember that, every time you apply a layer of paint, the previous wash must be dry to avoid disturbing it. Each layer also covers more of the white paper and becomes progressively more opaque. Try, therefore, to restrict yourself to a maximum of three colour layers in order to avoid mud. Wherever possible, get your colours and tones established in one stage, being bold and brave. Mud tends to result from overworking so the less work you do, the greater your chance of success.

To achieve a unified painting, always plan your colours before you begin.

► Pale Rose
15 × 17 cm (6 × 7 in)
I left crisp-edged chunks of untouched white paper to suggest sunlight catching the rose petals. I mixed many diluted colours into the background then re-used them to shade the flower where the colours were reflected. The golden stamens also glow onto the surrounding petals to create further warm tones.

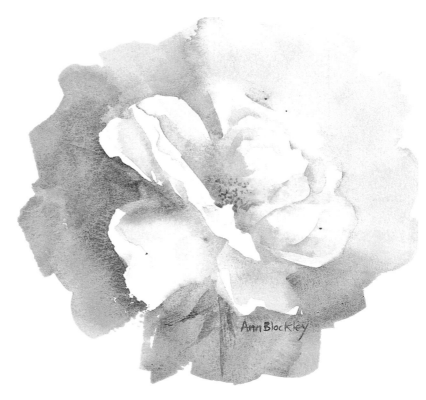

White flowers

To keep white flowers clean and fresh, you should retain as much white paper as possible. Work cautiously – the more paint you add, the greater the risk your flowers will become dirty. Keep superficial surface details to a minimum. If you overdefine, you can lose the sense of mystery. Textures and minor shadows should take second place to the overall lighting and structure of your flowers.

Sometimes white flowers contain quite strong tones, even appearing darker than the background. Don't be afraid of this, as shadow will throw up any white areas in greater relief. Use strong background tones if you want pale flowers to really dazzle and less contrast if you are aiming for a softer, more magical atmosphere.

Shadows

In order to explain a flower's form, you need shadows. With white flowers in particular, it can be difficult to decide what colour to use. Try not to mix homogenised, nondescript greys, as these may look dirty. Keep shadows colourful. In strong sunlight or at sunset, cast shadows are clearly blue or mauve, so these are obviously good colours to use. At other times, it's less easy to see specific tints. In these cases, remember that both whites and shadows reflect the colours they are close to. Therefore you can safely shade white flowers and colour shadows with pigments already mixed in your palette for their backgrounds.

If you want to mix a colourful grey, combine reds, blues and yellow in different ratios. Try variations of Raw Sienna, Cerulean Blue, Cobalt Blue, French Ultramarine and Crimson Alizarin.

◄ **Bindweed**
7.5 × 6 cm (3 × 2¹/₂ in)
Strong shadows describe the sunlit form of this bindweed. I merely hinted at the centre, which was buried in the shadowy base of the flower trumpet.

Mixing greens

Many artists find it surprisingly difficult to mix greens. In nature, greens can vary tremendously from cool blue tones to warm yellowy shades.

A wide variety of greens can be mixed using two methods. The first is to squeeze a green such as Sap Green or Viridian straight from the tube. This will rarely be the exact colour you want but you can go on to modify it with touches of other pigments to achieve a specific tint. Ask yourself whether your required green leans towards yellow or blue and if it is cool or warm, and this will help you choose an appropriate additional

pigment. However, remember that the merest hint of a new colour may have a big impact, so take it slowly.

The second method of mixing greens is to combine blues and yellows. Experiment and try lots of combinations to find a particular green. Start with a blue and add first a cool yellow like Lemon Yellow, then mix another version adding a warm yellow such as Indian Yellow.

A third warm browny tint could also be made by adding Raw Sienna. Now try using a different blue as your base colour. Use a dark blue like French Ultramarine for a dark green and a pale blue such as Cerulean Blue to make a lighter colour.

▼ **Water Lily**
35 × 43 cm (14 × 17 in)
I rarely limit myself to a single shade of green. For this watery scene, I mixed a wide range of different tints using combinations of French Ultramarine, Indian Yellow, Cerulean Blue, Lemon Yellow, Sap Green, Cobalt Blue, Green Gold, Viridian, Raw Sienna and a touch of Permanent Magenta.

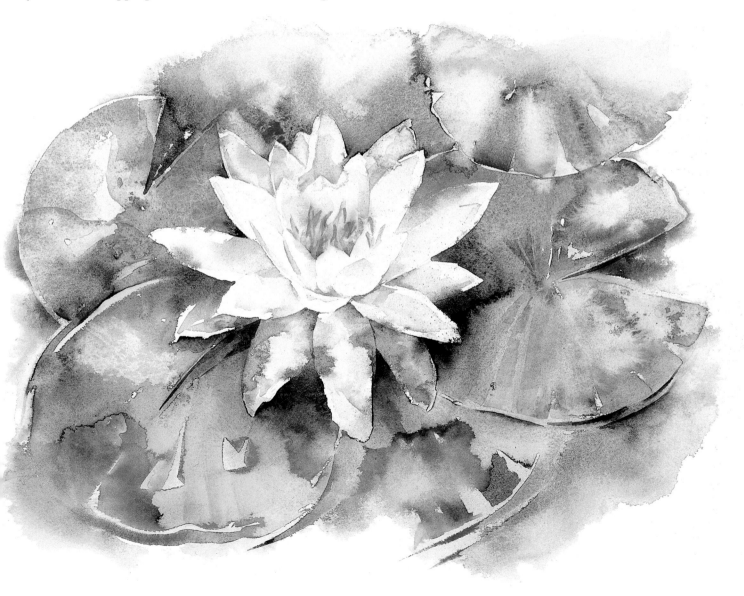

Looking at Flowers

Before you begin a flower painting, take a really good look at your subject. Ask yourself what it is that gives this flower its own special quality. Every flower is different – each has its own form, shade, size, colour and growing style. I am not concerned with formal labels for separate flower types. Botanical books categorise them into cups, bells, trumpets, rays and so forth. I am only interested in abstract qualities – spacing, proportion, edges, textures and shapes. I see flowers as jagged, frilly, curvaceous, chunky, gappy, solid, busy or simple. Every nuance of light and each viewpoint will affect the appearance and positioning of the flower parts.

Choosing a viewpoint

Always look at the subject from every angle before starting, just as you would if painting a portrait. The daffodil is a nightmare to draw face-on but, in profile, the trumpet is shown to its advantage. In contrast, the sunny rays of a dandelion are diminished when viewed from the side. In a group of flowers, you could show a variety of positions, giving a range of information about the flowers from the back, front, side, below or above. You may also wish to include various stages of growth.

Try to perfect your powers of observation, sometimes squinting to cut out detail and pare down information. Judge with your eyes, not your brain. You can never be sure that a feature is a certain size or proportion. Make sure, for example, that petals are the right shape. You can change the whole personality of a flower just by misjudging the gaps between petals. Some lead right into the centre, while others are gently scalloped. Flowers are often not symmetrical and frequently will surprise you. Observation and variety are the keys to successfully capturing individual character.

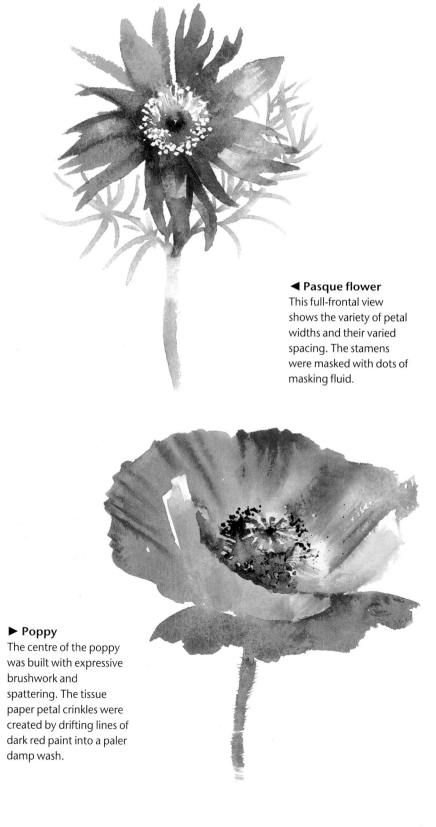

◀ **Pasque flower**
This full-frontal view shows the variety of petal widths and their varied spacing. The stamens were masked with dots of masking fluid.

▶ **Poppy**
The centre of the poppy was built with expressive brushwork and spattering. The tissue paper petal crinkles were created by drifting lines of dark red paint into a paler damp wash.

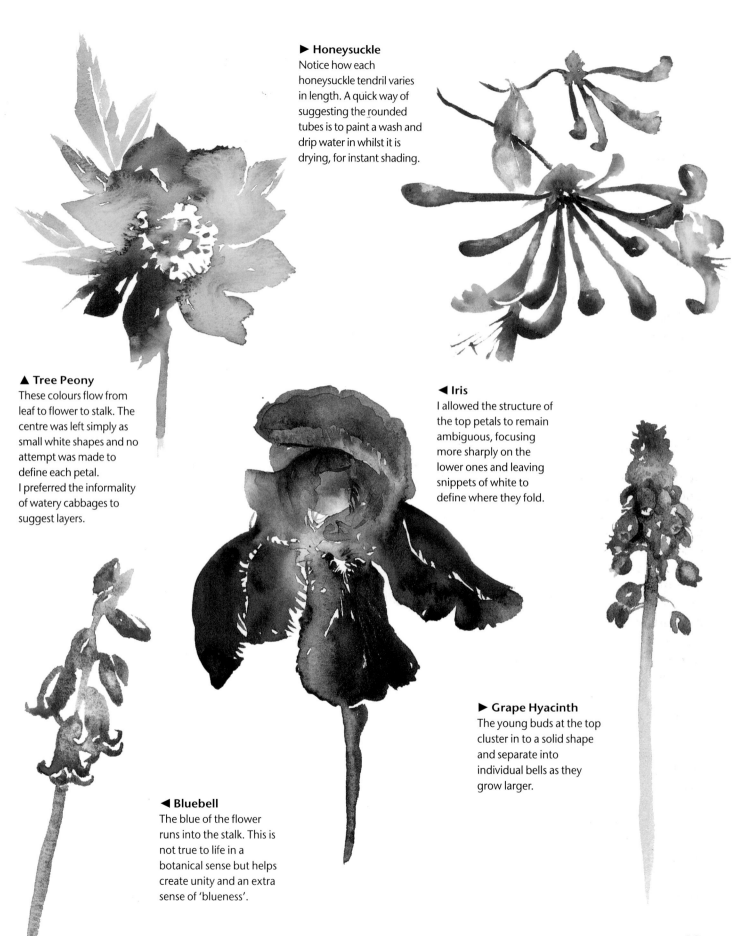

► Honeysuckle
Notice how each honeysuckle tendril varies in length. A quick way of suggesting the rounded tubes is to paint a wash and drip water in whilst it is drying, for instant shading.

▲ Tree Peony
These colours flow from leaf to flower to stalk. The centre was left simply as small white shapes and no attempt was made to define each petal. I preferred the informality of watery cabbages to suggest layers.

◄ Iris
I allowed the structure of the top petals to remain ambiguous, focusing more sharply on the lower ones and leaving snippets of white to define where they fold.

► Grape Hyacinth
The young buds at the top cluster in to a solid shape and separate into individual bells as they grow larger.

◄ Bluebell
The blue of the flower runs into the stalk. This is not true to life in a botanical sense but helps create unity and an extra sense of 'blueness'.

33

Building Flower Forms

Draw the basic forms of your subjects first with a soft pencil. Sketch in as much as you feel comfortable with but try not to include lots of detail at this stage, as it will tighten up your painting. Sometimes it is liberating to paint without preliminary drawing but, while you are learning, it is safest to do at least a brief outline to give you confidence.

Before you begin to paint, you need to decide if any pale areas need preserving, either with masking fluid or by painting around them. In watercolour, you work from light to dark, so any pale centres, veins, stamens or sunlit petals need to be planned at the start.

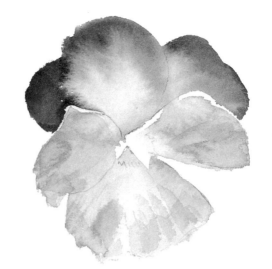

◄ I painted a pale yellow wash over the whole pansy except for a few highlights where the petals would overlap, then added magenta to the top petals, shading it back into the yellow with water.

▼ The dark markings were made with dryish paint, then a further layer of thick paint was added to give a velvety texture.

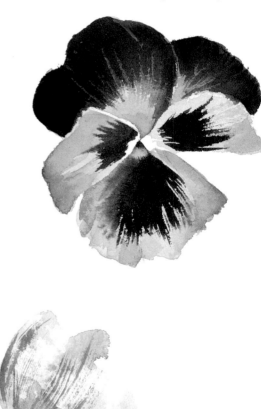

▲ I painted a wash over the whole crocus shape, then dropped yellow in wet-into-wet to suggest the flower centre.

► I added another layer of darker paint in simple shapes to give the three-dimensional form of the crocus. The first wash now became the paler front petals.

► Stripes, patterns or veins can be brushed over dry washes.

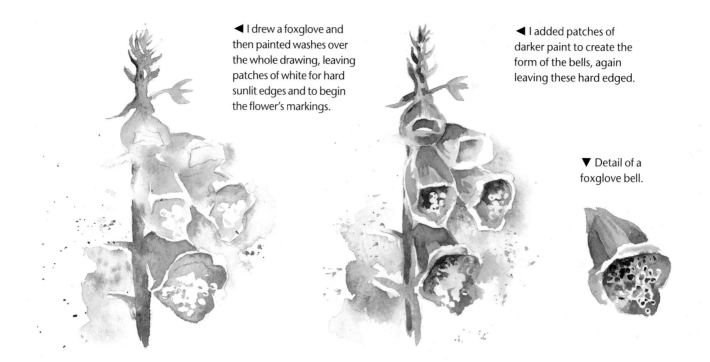

◄ I drew a foxglove and then painted washes over the whole drawing, leaving patches of white for hard sunlit edges and to begin the flower's markings.

◄ I added patches of darker paint to create the form of the bells, again leaving these hard edged.

▼ Detail of a foxglove bell.

► I painted a wash of Permanent Rose and Cobalt Magenta, then touched Indian Yellow in to suggest a soft, diffused centre.

▼ While this was still damp, I drew in green details with the tip of my brush.

You can build your flowers up in layers with small graded or variegated washes. When each wash is dry, add darker tones to create the form you need. I usually only use three layers, picking out individual petals, florets or details in the final stage. Try not to develop each area of your plant separately since this tends to give a disjointed appearance. You want your flower to look as if one part is growing out of the next. The colour of centres, for example, can be indicated in the first wash and sharpened up later. The result is not as natural if you leave a hole to 'fill in'.

► Once this was dry, I defined the central star shape with tiny brushstrokes and firmed up the middle.

Painting Petals

When we think about flowers, it is mainly their petals that stay in our memory. These appear in an infinite number of guises – some are layered and complex, others are single or simple. Their formations vary dramatically. Textures can be waxy, velvety, translucent, silky or crumpled. Patterns, markings and veins are other features to be considered.

With all these factors to describe, it is easy to become distracted and to let surface detail dominate the overall structure. Form and shape should take precedence over pattern and details.This does not mean that you cannot include detail, but try to contain it within certain parts of a painting. Be selective, put detail in focal areas and leave things plain elsewhere. Alternatively, offset sharp detail with paler or softer work.

▶ **Anemone**
23 × 23 cm (9 × 9 in)
Brushwork was applied on top of a dry wash to describe the veins and lines of the anemone petals. The centre was suggested with crisp dots of black paint which were smudged on the shadowy side.

▼ **Clematis**
17 × 20 cm (7 × 8 in)
The purple petal markings were drifted into a pale, damp wash to keep them soft edged. I put in hard, dark brush lines to suggest the centre once the petals were dry.

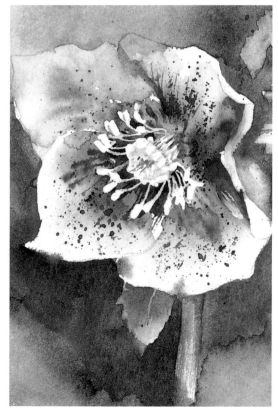

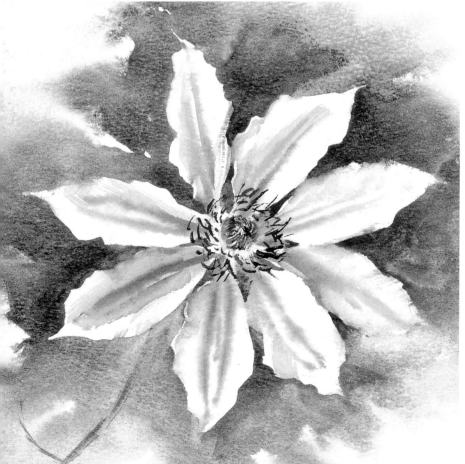

▲ **Hellebore**
15 × 10 cm (6 × 4 in)
The pale stamens were masked before painting dark washes over them. The speckled patterns were splattered on afterwards with a palette knife.

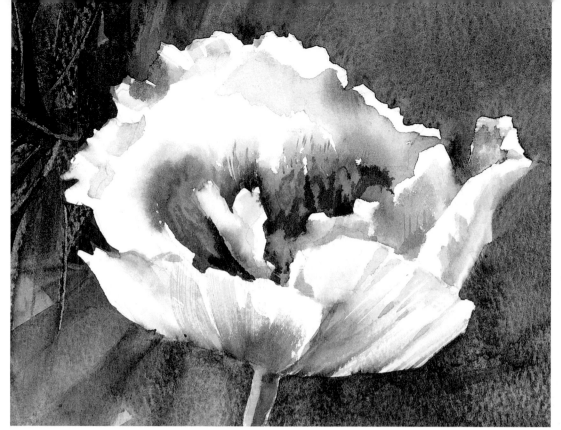

◀ **Peony**
15 × 17 cm (6 × 7 in)
The dark centre is crisp at
the bottom to throw the
pale front petals forwards.
The back edge is softer to
help it recede.

▼ **Water Lily**
20 × 17 cm (8 × 7 in)
I brushed a yellow wet-
into-wet wash over the
water lily centre while
painting the pink
petals, then followed
this by adding harder-
edged marks on top
when it was dry.

The same guidelines apply to painting a number of overlapping petals, where it is easy to become confused. Keep squinting at the flower to block out detail. Only the stronger shadows will be clear, and these are the ones you should paint. If you get lost and have to struggle to work out the structure of the flower, you are working too hard!

Flower centres

Stamens, anthers and pistils are scientific names for the central parts of a flower. I think of them as being different-sized dots, dashes, spots and splashes, thin and thick lines, dark and light. Practise different techniques and brushstrokes to render these multifarious marks, and look on pages 22–25 for ideas.

If the centres are pale, you will need to mask, lift, or bring them out of a wash in negative painting. If they are dark, they can be painted on top of a paler, suitably-coloured wash. Always check that your centre is in the middle and that it will lead through into the stem from whatever perspective you are viewing it. Sometimes you will not be able to see the centre at all, or it may be hidden in soft shadow.

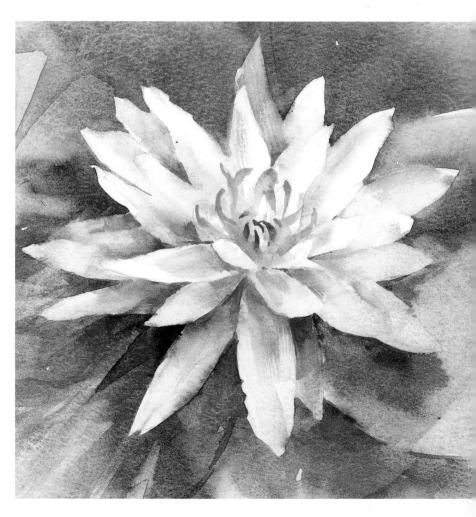

Simplifying Flowers

Many flowers have flamboyant or complicated structures that may seem terrifying to paint. Pompom layers of petals, spires of bells and clouds of florets are all complex. The trick of painting some intricate forms is to be selective. Pick out the important or obvious shapes and anything uncertain or confused can be dealt with in ambiguous general washes. If you concentrate detail in certain parts of the flower, the larger areas can be left to explain themselves. I feel that the artist should leave some work for the viewer to think about.

I have mentioned before my trick of peering at a subject through half-closed eyes. Blurring and shutting down detail in this way makes it easier to understand your subject, as only important aspects are highlighted. In fact, if you are short-sighted, you could try taking off your spectacles!

When you simplify a complex subject, your drawing needs to be succinct, with the key elements in the right proportion and place. When you leave out details, the remaining elements must be informative and convey accurately the flower's character. In particular, it is important that its overall shape or profile is recognizable, and then the rest of the subject can be described in a looser fashion. Don't just paint an outline and fill it in – the brushstroke should describe the entire shape.

Simple tonal values

A strong light source helps to break down a subject into the tonal pattern that describes its form. Try to reduce these to three basic values – pale, medium and dark. When painting outside, make a rough pencil sketch before you begin in case the light changes. If you are working indoors, you can use artificial light. The brighter this is, the easier it will be to see the structure of your subject. Don't be afraid to use the white of the paper for your lightest areas. Again, a preliminary tonal sketch can help to clarify tonal values. Once these have been established, I usually put most detail into the mid-value tones, working over a base wash with positive or negative painting.

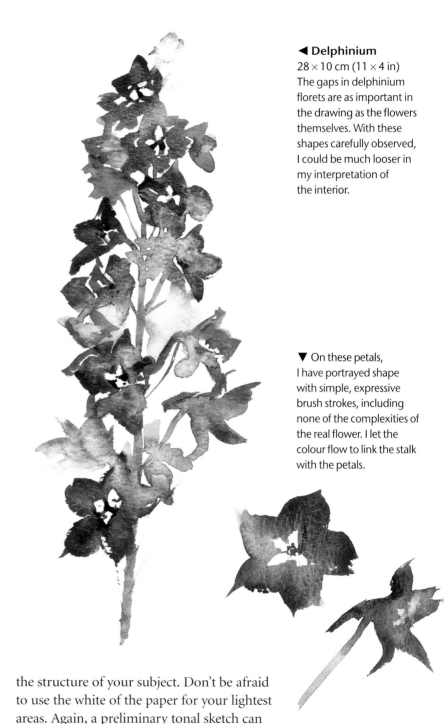

◄ **Delphinium**
28 × 10 cm (11 × 4 in)
The gaps in delphinium florets are as important in the drawing as the flowers themselves. With these shapes carefully observed, I could be much looser in my interpretation of the interior.

▼ On these petals, I have portrayed shape with simple, expressive brush strokes, including none of the complexities of the real flower. I let the colour flow to link the stalk with the petals.

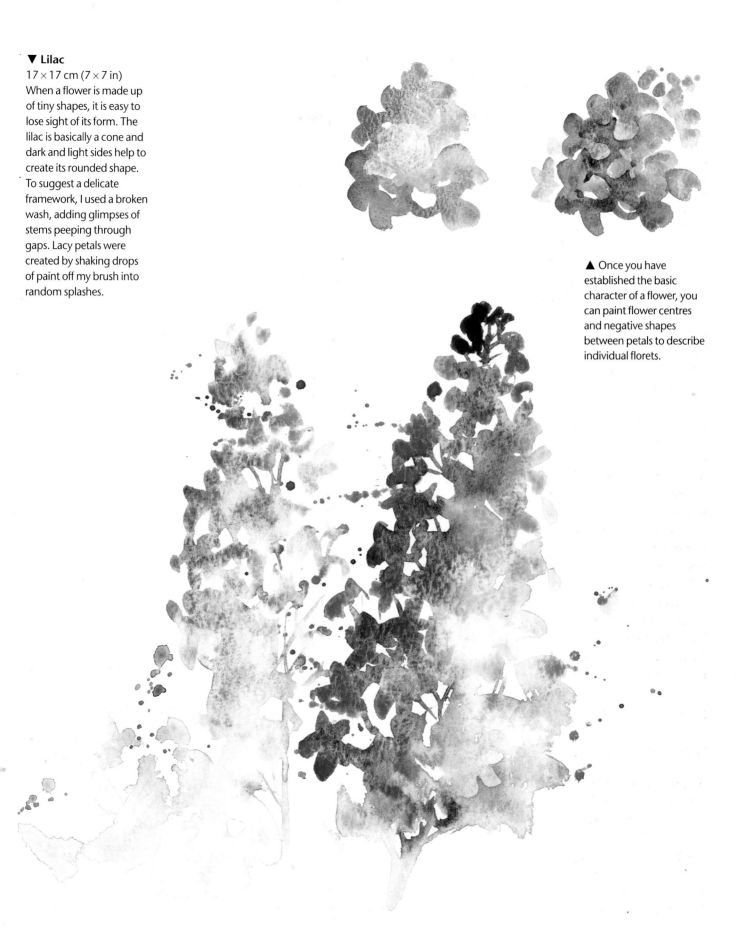

▼ Lilac

17 × 17 cm (7 × 7 in)

When a flower is made up of tiny shapes, it is easy to lose sight of its form. The lilac is basically a cone and dark and light sides help to create its rounded shape. To suggest a delicate framework, I used a broken wash, adding glimpses of stems peeping through gaps. Lacy petals were created by shaking drops of paint off my brush into random splashes.

▲ Once you have established the basic character of a flower, you can paint flower centres and negative shapes between petals to describe individual florets.

Leaves and Stems

Leaves are the perfect foil for flowers. They either complement them, or help to throw them out from the background.

Leaves should always be treated as an important element of your painting. They are certainly not an arbitrary afterthought or something to 'fill a space', even if you wish to treat them in a loose, impressionistic way.

On the other hand, be careful not to over-emphasise them if their role is as backdrop rather than focal point. For this reason, I mask leaves and stems infrequently, since this method can make them too crisp edged and important. Often only a few can be seen individually and the rest should merge into a jungle of background texture.

Background leaves

These can be developed out of background washes in various ways. Cabbages can be adapted into interesting foliage. Dark leaves can be simply painted on top of a light wash. Pale leaves, however, need to be carefully planned. You can try lifting colour, masking or negative painting. I find this last method is extremely useful because you can achieve crisp edges where leaves are well defined but 'lose' edges where they are less clear. Plain negative shapes can be painted in with more detail.

To create the effect of overlapping leaves weave darks and lights, positives and negatives and lost-and-found edges.

▲ When painting a mass of foliage, simplify things by squinting at the overall view to cut down detail. This way, you can identify several key shapes and describe the rest as abstract pattern.

▼ **Stems**
This series of stems was painted with a range of different methods. From left to right: lifting, masking and shading, negative painting, wet-in-wet, wet-on-dry, a combination of wet and dry, and a combination of negative and positive marks.

a To make leaves fold and catch light on one side, paint a wash over the whole leaf, then lift or blot out the paler half.
b Use layers of tone to create folds and curls. The underside of a leaf often looks paler than its top.
c With autumn leaves, you can try different colours and techniques. Use dry brush and scraping for brittle textures.
d Different brushstrokes create a range of leaf shapes.
e Link colours from the stem into the leaves using a sharp brush tip to paint into serrated edges. Dark veins can be added on top of the dry wash.
f Drip water into damp paint for mottled effects.
g Wet-into-wet is ideal for picking out soft gradations of colour.
h Combine varieties of green within each leaf. An angled brush is useful for sharp edges.
i Round brushes cope better with wiggly shapes.

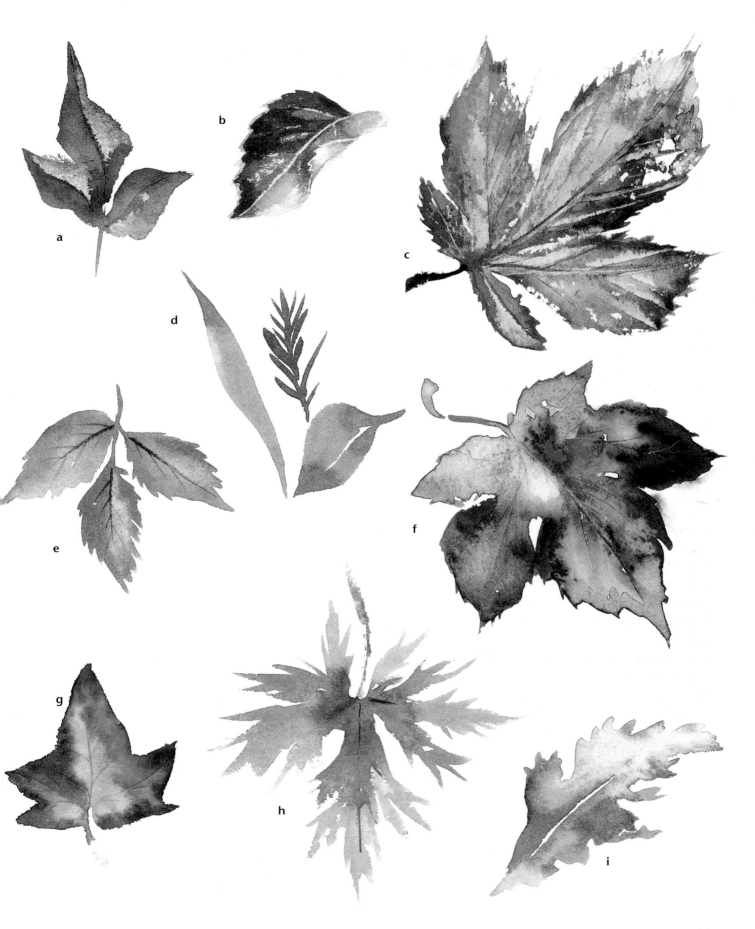

a

b

c

d

e

f

g

h

i

Composing a Picture

Before you paint a complete picture, it is important to plan its composition. This rather formal expression simply means placing different components into an interesting arrangement. My method of starting a design is to sketch the leaves and flowers in various shapes and sizes onto separate pieces of tracing paper. I then juggle them around until their positions 'look right', before drawing the design onto watercolour paper.

Aesthetic decisions are a personal choice and you should always follow your instincts. With practice, you will learn why some arrangements succeed more than others. I have noticed certain formulas emerging in my own painting and will deal with these in the following pages.

Contrasting elements

An interesting composition usually contains a variety of contrasting elements. A group of flowers, for example, may contain blooms which vary in size. If necessary, you can – within reason – reduce or exaggerate some members of the group in order to avoid repetition.

Subjects can also be viewed from a variety of angles to present a range of different and contrasting shapes. Whether you are painting from life or photographs, you can move the subject around and make changes to suit your picture, as long as you avoid resorting to unnatural distortions. Also, try varying the spaces between objects. Some flowers could overlap or be close together while others could sit further apart. You will find that sometimes the shapes found in between the flowers in your paintings are as important as the subjects themselves.

Avoid geometric patterns

One thing to be very wary of is placing equal-sized subjects in straight rows or obvious geometric patterns – placing flowers in a wreath or at the points of an equilateral triangle or square is a common mistake that new artists make. Symmetrical designs are much more interesting if they are broken up by changes of size, position, colour or shape.

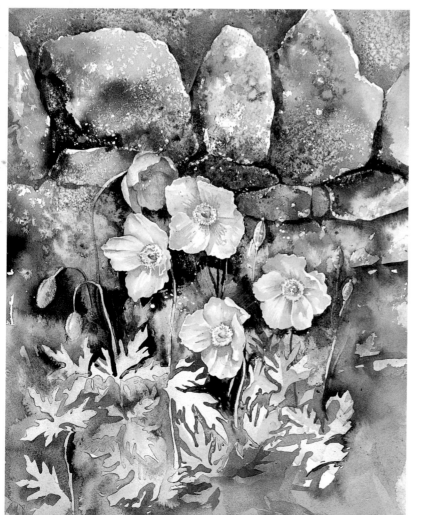

▼ Welsh Poppies
25 × 17 cm (10 × 7 in)
There is plenty of variety to be found in this design. The smooth flowers are in complete contrast to the rough background of the stone wall.

► White Roses
45 x 38 cm (18 x 15 in)
Irregular spaces between petals help flowers to create their own unique shapes. The two blooms in the foreground are larger than the others and placed at an asymmetric angle. Imagine the dull symmetry of this composition if they were side by side.

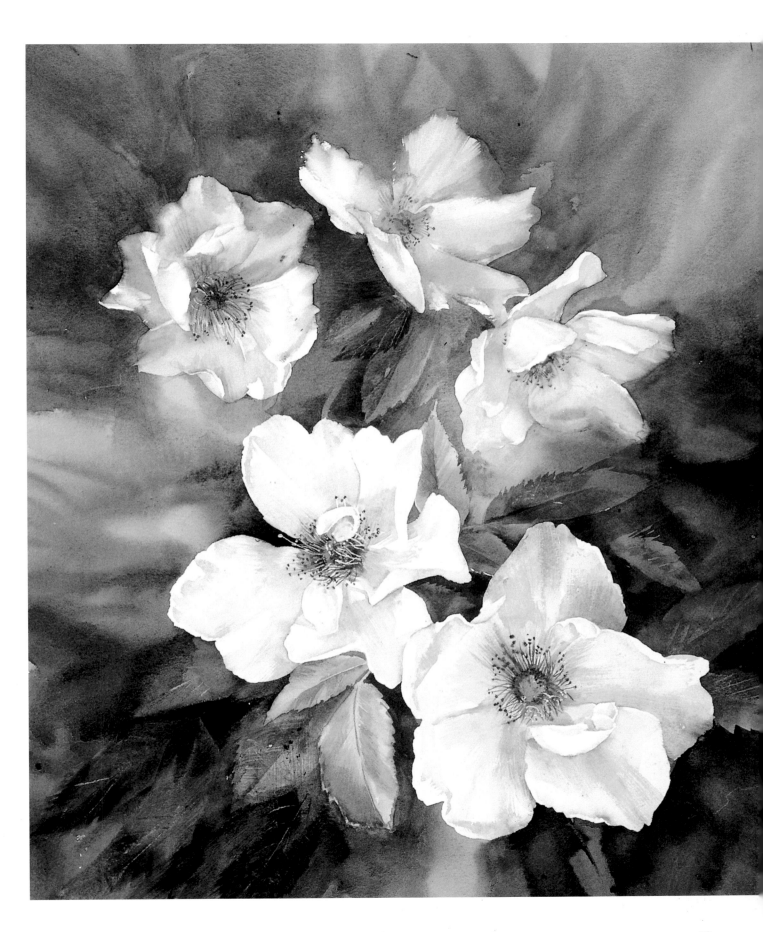

Choosing your Subject

Sometimes the most difficult aspect of picture making is deciding what to paint! A vaseful or even a whole garden of flowers can make you feel spoilt for choice. Always pick what appeals to you most and not what you think you ought to paint. Only by doing this will your paintings be full of life and feeling.

Using a viewfinder

To help you make your choice, try looking at the subject using a viewfinder. Take two L-shaped pieces of card and hold them at right angles to each other to form a frame. This can be opened out for a panoramic scene or closed in to focus on a small detail. With practice, you will be able to do this in your head. Frame rectangles or squares of all shapes and sizes around the subject to find an arrangement that strikes a chord. If you can't find a composition that balances quite to your satisfaction, don't be afraid to move objects within your painting.

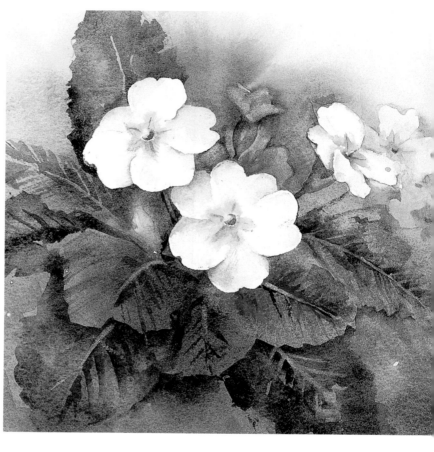

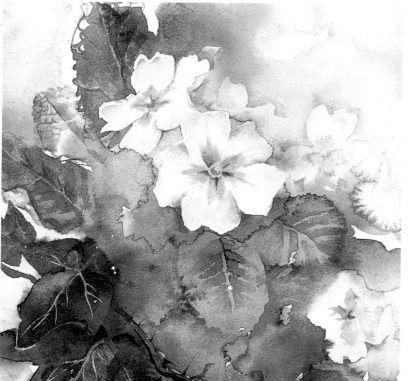

▲ **Primroses 1**
23 × 20 cm (9 × 8 in)
A simple pot of primroses provided me with lots of painting ideas. This interpretation plays on the contrast between the smooth, pale primroses hovering like butterflies above the dark rosette of ridged leaves. The brushwork is controlled and tight to convey the almost old-fashioned or traditional nature of the subject.

◀ **Primroses 2**
20 × 20 cm (8 × 8 in)
For a different version of the same primroses, I draped ivy around the pot. This simple addition immediately suggests a wilder, woodland theme. I allowed my paint to flow in a looser fashion than in the first painting, encouraging ragged-edged backruns to suggest crumpled leaves. I also let colours and edges seep and merge to retain a natural, informal approach.

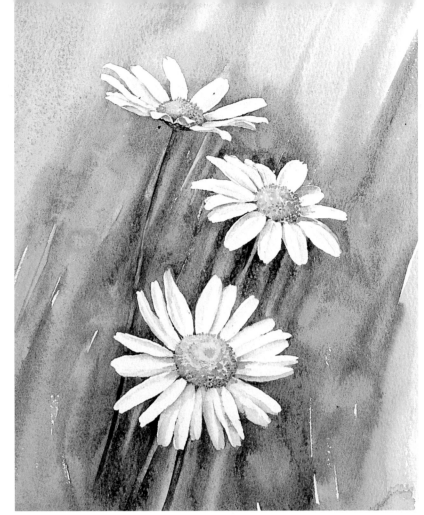

► Daisy Meadow
28 × 20 cm (11 × 8 in)
This painting is a composition of three flowers viewed from various angles. The buttercup meadow behind dissolves into a blurred wet-into-wet wash to keep attention focused on the flower trio.

▼ Fresh as a Daisy
23 × 20 cm (9 × 8 in)
This second picture zooms into the foreground flower featured in *Daisy Meadow*. It stares towards us and its centre is examined in detail. I wanted a clean, fresh image so I chose a bright yellow background to represent the cheerful subject and used bright green to contrast with the crisp white petals.

Be selective

Decide upon your subject's main attraction and tell its story with paint. Is it the light shining through petals, a tapestry of textures, or a combination of colours that attracts you? Be selective and concentrate all your efforts into capturing the specific qualities on paper.

A writer uses words to describe the scene whereas a painter's tools are abstract qualities such as edge values, colours and shapes. As you develop a painting, ask yourself continuously if you are contributing to the subject's character. It is easy to be sidetracked into added detail, new pigments and extra leaves or flowers that may not actually help your story line. Most subjects contain more than one aspect of interest and restraint is vital. In our enthusiasm to create interesting designs full of variety and surprise, we can easily end up with a restless painting. The eye needs peaceful areas to balance busier elements.

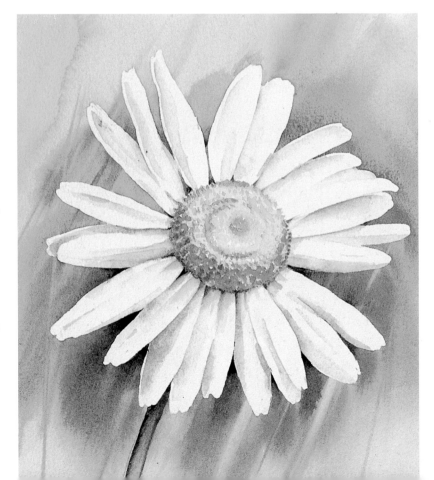

▼ Gladioli
53 × 25 cm (21 × 10 in)
A slim, vertical format
suits these tall flowers. The
sharp edge values of the
foreground gladiolus
make it stand well in front
of its softer neighbour.

Size and format

Once I have chosen my subject, I can plan the shape and size of the finished picture. This decision plays a large part in the visual storytelling. I never prepare paper in advance because only at this point will I know if an entire sheet, a narrow strip or chunky square is required. It makes sense, for example, to paint a massive sunflower as large as possible or a tiny forget-me-not in miniature form.

Echoing the growth pattern of a plant in a painting is an effective technique for displaying a subject's character. Also a dramatic statement can be made by magnifying a subject hugely. Almost always, I would recommend painting at least slightly larger than life to avoid finicky work.

Creating a focal point

Whatever its size or shape, a painting should have a focal point – the part of it that attracts attention first. The picture may contain other interesting features but this main attraction should always draw the viewer back.

A subject can be made prominent by size, colour, degree of detail or contrast, edge value or position. A large, vibrant, closely-observed, hard-edged flower would dominate a hazy, subdued, sketchy scene. Busy areas catch the eye, whereas we skim over plainer passages. Leaves, stems or even brush marks can be placed to lead the viewer's eye in certain directions. Flowers that face you tend to be more commanding than those that turn away.

A picture with a definite focus often contains a strong sense of depth and secondary elements recede or sink into the background to create a three-dimensional quality. It is similar to the effect of a camera lens that focuses sharply on a subject until everything else becomes a blur. I view all my subjects as if I were a camera, particularly if I am faced with something complex. I peer through half-closed eyes to block out unwanted detail. To simplify things, I think of my pictures as having three basic planes – a foreground which may often contain the focal point, an out-of-focus background and an ambiguous medium ground.

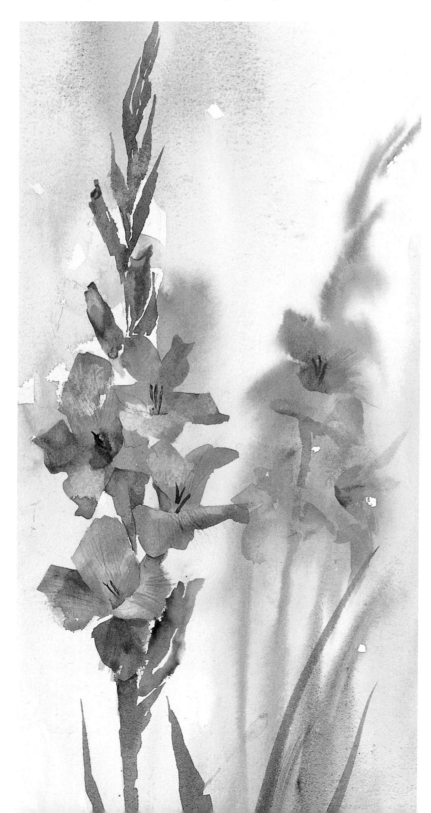

▶ Peonies
73 x 53 cm (29 x 21 in)
Depth was created with tonal contrast. The pale, crisp-edged peonies leap out of the dark, soft background, while the leaves melt into the wash becoming paler at the top to create distance.

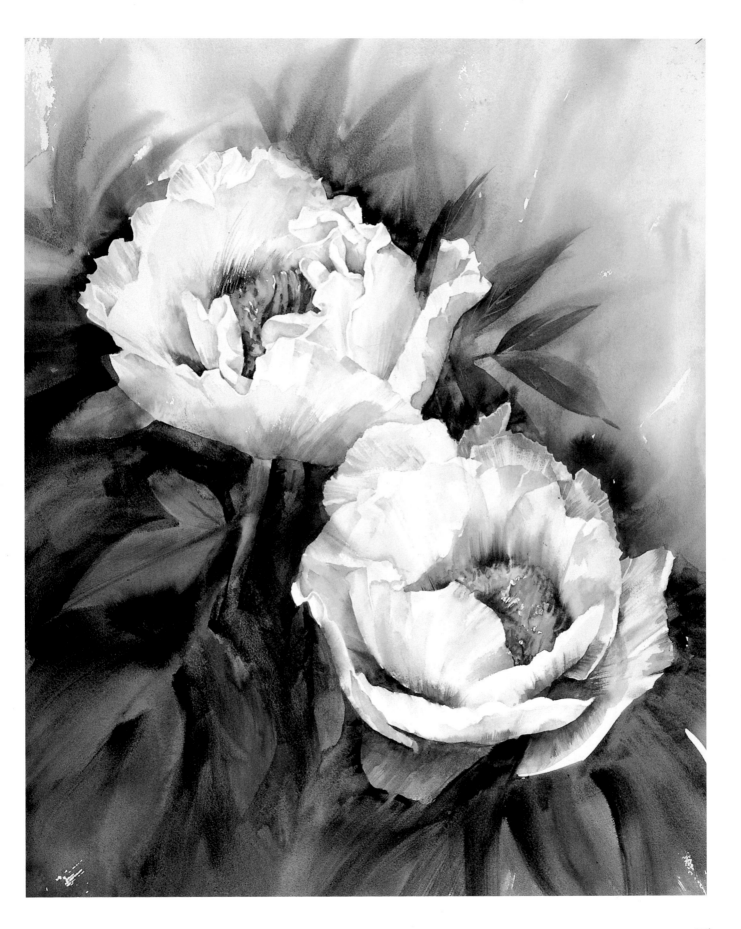

Backgrounds

There are many advantages to including a background in a flower painting. It gives the opportunity to add depth, distance and an impression of quantity. You can place subjects in different settings and create a variety of moods – a single flower set on a white paper may look striking but it does not tell as complete a story.

The background is an integral part of a painting and not a separate element or afterthought. It should reflect its foreground and vice versa. They must both be planned from the beginning but the big question is which to paint first?

When I was learning to paint, I thought backgrounds were quite scary and found it easiest to start with them. This way it was not quite so disastrous if they went wrong, because not too much time was wasted. It also forced me to plan ahead. I had to choose background colours at the very beginning. I based my choice loosely either on the type of atmosphere, the time of day, or the season I was trying to describe. I usually included some of the flower colours to help develop links with the foreground. I suggest that you start this way.

Tonal values

Tonal values also need to be planned before beginning a painting. Light backgrounds throw dark subjects into dramatic silhouette. Conversely, dark backgrounds can emphasise pale flowers and petals.

For extra interest, vary tones throughout your picture with pale washes at the top, bottom or in one corner. Try to incorporate a combination of light-on-dark and dark-on-light, especially in your background leaves and stems. This, along with varied edge values, helps the foreground to integrate with the background and not merely seem placed on top.

The tonal values of your subject will often dictate the order of work. If a subject is pale, paint the background around it or over masking fluid first, then fill in the space later. Alternatively, a pale wash of appropriate colour can be painted through the whole area and the subject pulled out in the next stage with negative painting. This last method is most useful when portraying background

▼ **Honesty**

25 × 17 cm (10 × 7 in)
This picture is so integrated that it is impossible to see where one thing ends and another begins. In places, the background textures become part of the honesty themselves.

Ann Blockley

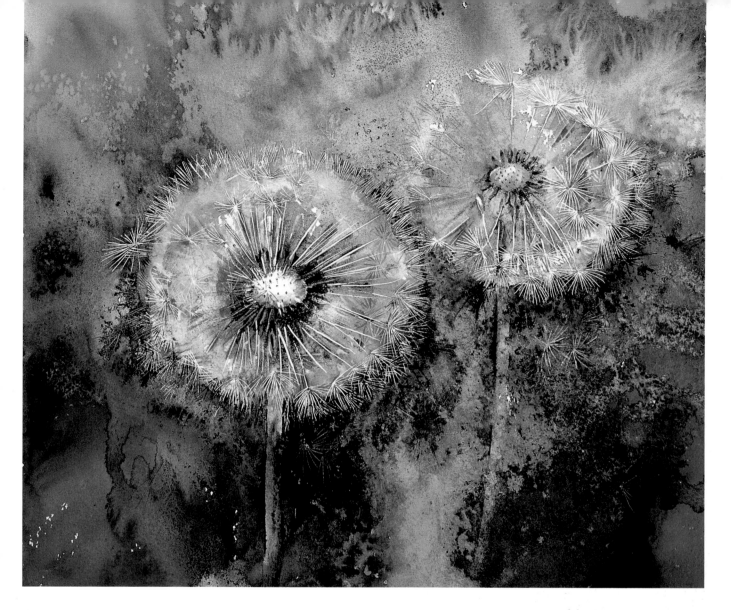

flowers that are not required to stand out prominently. A dark subject can be painted on top of a pale background, or described first and a wash brushed around it afterwards. You can also choose to mask the dark subject, even though it will ultimately be filled in with strong tones. A complex design may combine these different methods. There is no right or wrong way of working – you have to discover for yourself what suits your style best.

Putting in texture

The first stage of a background is a little like an undercoat and you do not need to be obsessive about every flaw. You will continue to work into parts of it, adapting marks and

textures, adding further washes and describing focal points. Washes do not have to be perfectly even or fill every part of the shape solidly. Specks or even large spaces of white paper add light and vitality. Broken brushwork can give an impression of background foliage and plant life.

So, relax and give your watercolour the freedom to flow and make happy accidents. Backgrounds are a fantastic opportunity to play with the texture-making ideas. Choose those that emphasise an aspect of your subject's character. A spiky thistle, for example, will require a different background approach to an elderflower. Be wary, though, of getting carried away with textures – always ask yourself if a more straightforward wash would be more suitable.

▲ **Sunset Clocks**
33 × 38 cm (13 × 15 in)
This picture was truly an exercise in texture making. I sprinkled salt into the background wash and splattered dots of paint to give an impression of movement.

Creating Atmosphere

I like pictures to conjure up a mood, a sense of peace or rush of passion. One of the joys of watercolour is its ability to change personality. It can be brooding and quiet, or powerful and strong. The colours, tones and methods we use all play a part in setting the scene. For example, warm pigments like reds are generally active and exciting. Cooler blues are more calm and gentle.

Of course, each colour varies – there are cool reds and warm blues and you must choose each pigment individually to

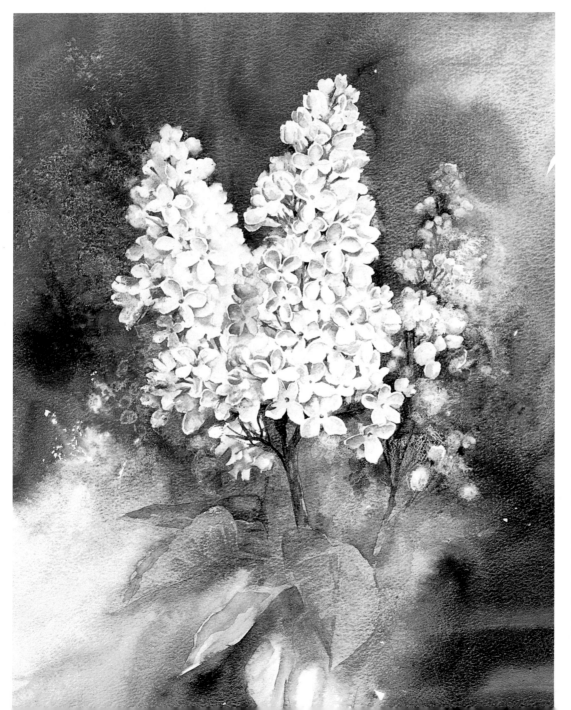

◀ **White Lilac**
40 × 30 cm (16 × 12 in)
The foreground flowers were masked, giving me the freedom to sweep loose atmospheric washes behind them. I sprinkled salt and blotted texture out of the variegated colours to describe the background lilac.

emphasise your colour scheme. A strong sense of atmosphere can be achieved by using a limited palette. Drama results when a painting contains many tonal or colour contrasts. Similar tones, all pale or all dark, make thoughtful, subdued statements. Colours that harmonise will create a quieter mood than those that clash or sing.

A touch of mystery

Choice of technique also has a powerful impact on the impression created. Choose a large expanse of smooth wet-into-wet washes and blurred or feathery brushstrokes to create mystery, or use busy mark making, crisp edges and hard lines to build up a more fresh and lively atmosphere. Decide at the beginning the mood you wish to develop to enhance a subject and remind yourself of this aim when making all your subsequent decisions.

Background flowers

The mood of a painting can be enhanced by including atmospheric background flowers. I generally treat these as loose impressions, giving only hints and clues about their identities. I leave the viewer to use their imagination in working out their own interpretation – they can make assumptions based on the facts supplied in the foreground flowers regarding shapes, colours, textures and patterns.

The idea of including minimal information is not, of course, an excuse for sloppy work! If the background marks are inappropriate, they would detract from the focal point and look like mistakes. To keep them meaningful, it is vital that your impressions echo certain aspects of the main subject.

If a new subject is being introduced in the background it should at least suggest real possibilities, however ambiguous. You may use wet-into-wet brushstrokes or texture and mark-making devices (see pages 22–25) to begin your flower suggestion.

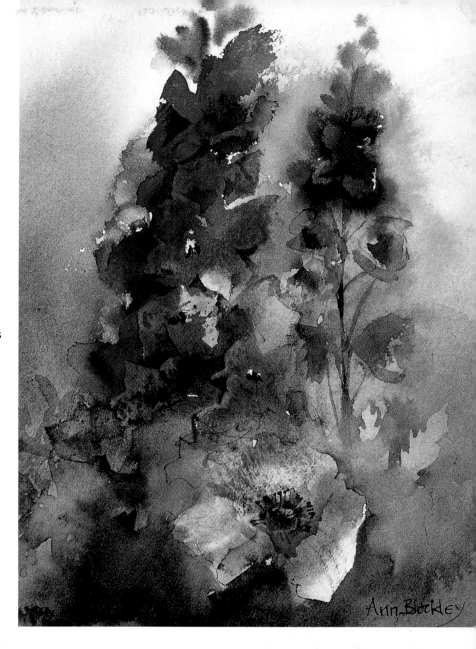

These abstract marks can be defined further, depending upon their importance and how far they retreat. A simple blur of wet-into-wet colour may be all that is needed to convey the idea of the most distant subject. A flower in the middle distance may require the extra definition of a centre or petal. Leaves and flowers can be magically conjured out of background washes with negative painting. Some of the edges can be clearly described, others left to the imagination. Remember that the success of a painting often depends as much on what you leave out as what is included.

▲ **Delphiniums**
23 × 17 cm (9 × 7 in)
This picture relies on abstract qualities to create a romantic mood. Edges are ragged or blurred, colours merge, and crisp negative shapes pick out elements of the flower structure.

Foxglove

*In my garden, foxgloves seed themselves each year
under a shady hawthorn tree. Sometimes
shafts of light pierce this dark corner, illuminating
them into sharp focus against the shadowy background
of the other flowers. In fact, I know these to be
blue campanula but have kept this a secret in my
painting, merely hinting at their identity
through colour and suggestion.*

▶ First stage

Colours

 Cobalt
Blue

 Quinacrodine
Magenta

 French
Ultramarine

 Indian
Yellow

► Second stage

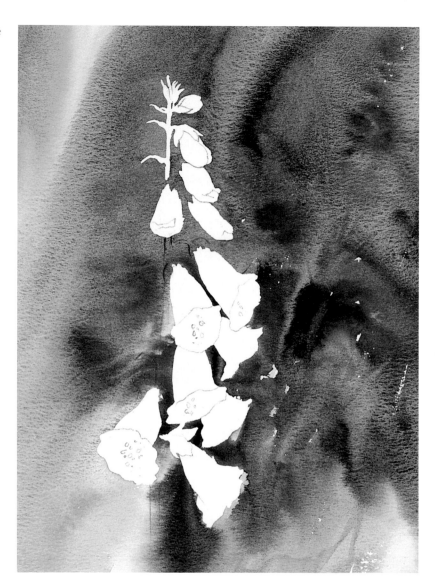

First Stage

I drew the outline of the foxglove, portraying the overlapping bells as one large shape. I placed the upright form carefully so that it was not quite central and that the bells fell into an interesting arrangement. I masked the shapes but included only part of the stem as I did not want this to be as striking or dominant as the flowers.

Second Stage

I diluted French Ultramarine, Cobalt Blue and Indian Yellow, combining them in different ratios to create a variety of colours. I also added a minute amount of Quinacrodine Magenta to some of the Indian Yellow to lend extra warmth.

I painted variegated washes in a diagonal direction to offset the vertical foxglove, letting each colour merge with the next. A new mixture of French Ultramarine and a little Quinacrodine Magenta was used wet-into-wet on the background to create amorphous flower shapes. I deliberately placed dark colour behind part of the pale foxglove to create plenty of contrast.

I lifted one or two gentle stems out of the still-damp paint in the area of my 'mystery' flowers. Then I removed the masking fluid and drew more information into the foxglove with a pencil.

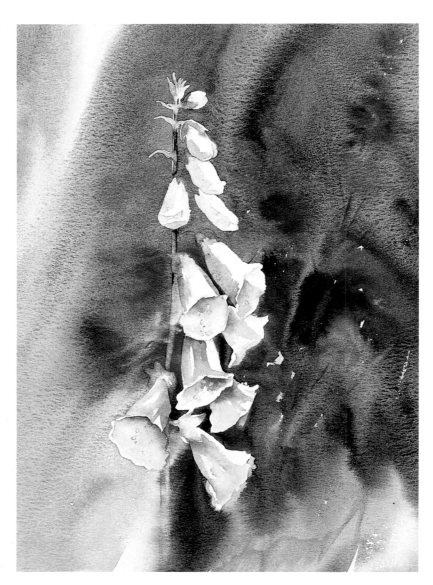

Third Stage

I began establishing the colours and tones of the flowers, noting the tonal difference that defined the dark interiors of the bells. I used Indian Yellow and a little Quinacrodine Magenta for the closed bells at the top, then gradually added more magenta in the open bells. The stem was tinted with a mixture of French Ultramarine and Indian Yellow, and I lifted some background paint with a damp brush to make a start on the lower stalk.

Finished Stage

I darkened the stalk until it was stronger than the background, apart from part of the lifted area which I left as a highlight. I used the same green to paint the sepals, shading in parts again to show where the light fell.

I continued working on the flowers, strengthening my tentative groundwork with more confident layers of the established colour. At this stage, it was important not to overwork things. In order to retain the bleached effect of sunlight, I took care to leave only the merest hint of a wash to relieve the white of the paper where the flower was palest, restricting darker colour to the shadows. I painted around the light blotches on the foxglove 'lips', leaving pale negative markings.

Finally, in the centre of these, I added dark spots that brought the picture to life.

▶ **Foxglove**
30 × 24 cm (12 × 9¹/₂ in)

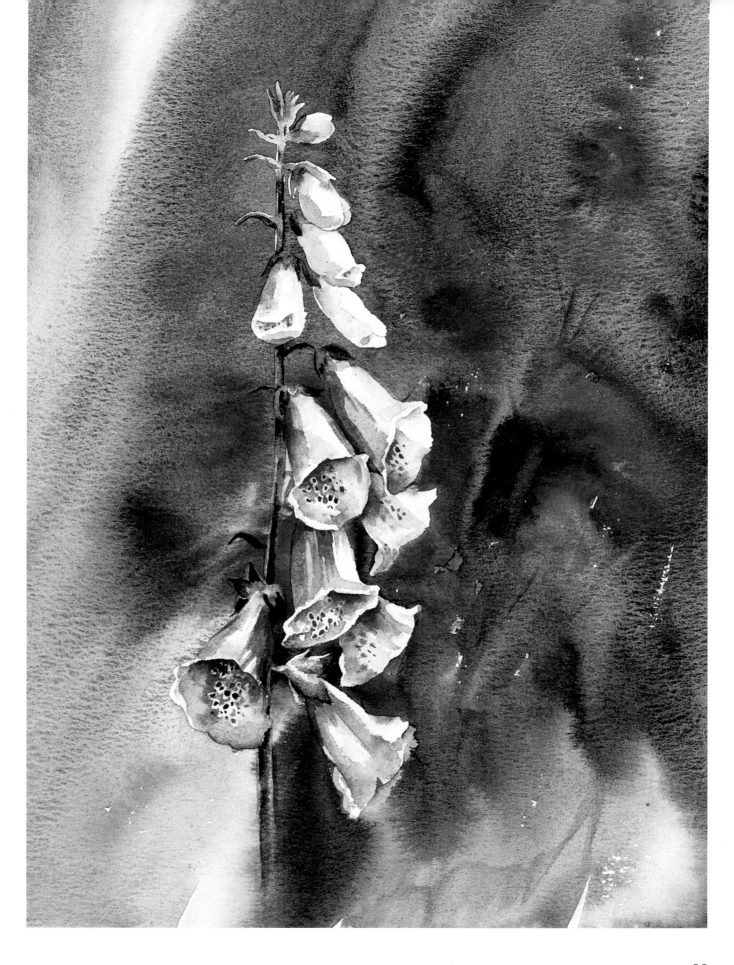

Lacy Hogweed

I love the delicate, lacy pattern that is the essence of this flower. Its structure is complex, intricate and well worth close scrutiny. However, my fascination here was with the overall impression – the multitude of tiny heart shapes, dots and wispy lines. They gather in clouds to weave a frail doily-like structure which can be shown to advantage against fresh and simple washes.

▶ First stage

Colours

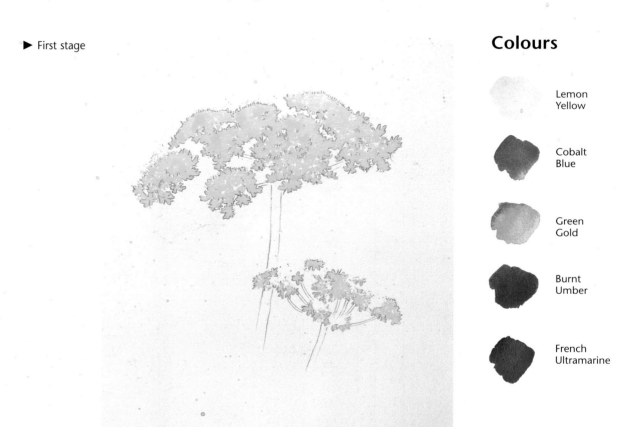

Lemon Yellow

Cobalt Blue

Green Gold

Burnt Umber

French Ultramarine

First Stage

The time-consuming part of this picture was in the preparation. First, I drew the hogweed, paying particular attention to any dominant petals around the edge of each group of florets. These were larger and more clearly-defined shapes than the unformed and overlapping central florets, which merge into a broken texture. Next, I painted masking fluid into the drawing, leaving random dots and spaces in the abstract areas but applying it carefully into the definite petal shapes and wispy stems. I left the secondary flower head more sketchy and less detailed than the main feature itself.

Second Stage

Then I mixed a series of washes, using combinations of all the colours to create different shades of blue, green and yellow. Starting at the top, I painted washes downwards with slanting sweeps of colour.

I used the palest colours above the main hogweed to make the far side of the flower recede, and then used darker tones underneath it to bring the front forward and to emphasise the petal shapes. I added wet-into-wet brushstrokes to suggest soft stalks and grasses.

While the washes were damp, I placed my wet brush into the sketchy right-hand flower to create a misty cauliflower. I also blotted a little colour out of the left side to begin a further flower head. I removed all the masking fluid when this was dry.

Finished Stage

As soon as I had removed the masking fluid, the flowers began to come to life and I could see which areas needed tidying up or adding to. I painted a pale wash around parts of the two flower impressions, creating negative petal shapes out of the cauliflower and blotted markings. I also painted dilute colour on parts of the main flower to separate and subtly shade the groups of flowers. I added a little restrained detail to the masked areas and added dots of Green Gold to describe the floret centres.

Next, I used darker tones of the background mixtures to paint more stalks and stems. I used the edge of a flat brush to paint the herringbone pattern of the grass heads. Because I felt that the overall effect was still a little bit stiff, I loosened up the whole picture by splattering paint onto it with the tip of my palette knife. This worked well – the flowers immediately look lacier and far more lively.

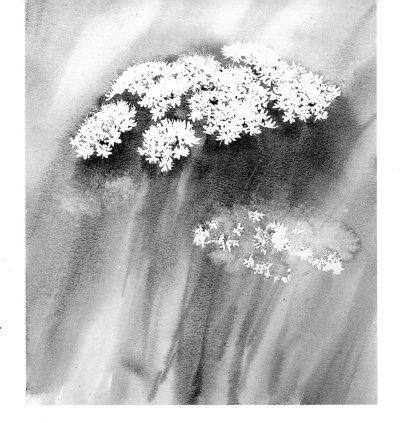

▲ Second stage

▼ **Lacy Hogweed**
34 × 28 cm (13 × 11 in)

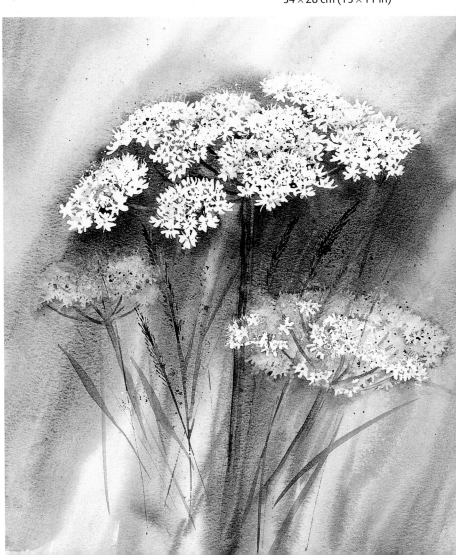

Pansies

With the open gaze of their velvety faces, pansies appear to be such friendly little flowers. They seem happiest in groups, surrounded by companions. For this painting, I chose a typical patch of pansies, focusing on two blooms – a dark one behind a contrasting paler friend. The other flowers merge into the background with progressively less detail.

▶ First stage

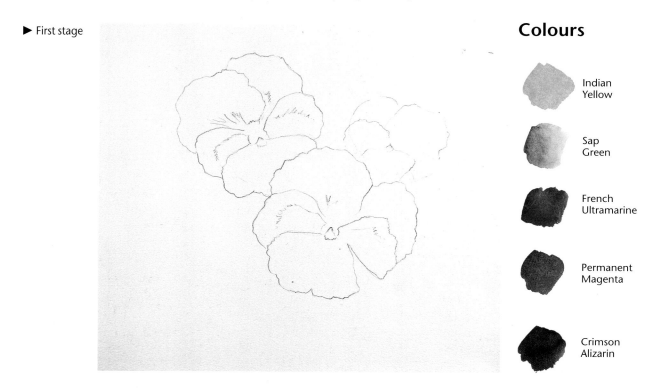

Colours

Indian Yellow

Sap Green

French Ultramarine

Permanent Magenta

Crimson Alizarin

First Stage

I drew the two main pansies, including their overlapping petals and parts of their markings. I placed them at an angle that pleased me, making the foreground flower slightly larger than the other. I also indicated a third flower as a confidence-builder, although I was prepared to lose this in the wash.

Next, I prepared the colours I would need for the background. Sap Green, French Ultramarine, Crimson Alizarin and Indian Yellow were combined into several washes, varying from bright greens and blue-greens to purples. These were all mixed together on the paper to create a range of further hues.

I had chosen not to use masking fluid, as I felt that the two main shapes were simple enough to paint around, so I had to work more carefully. I used clean water to dampen the part of the background where I wanted to begin. This meant that the initial brushstrokes were soft edged and would be easier to blend with the completed background than a dried hard edge. I kept the washes pale over the sketchy flower but painted a rich combination of Permanent Magenta and a little French

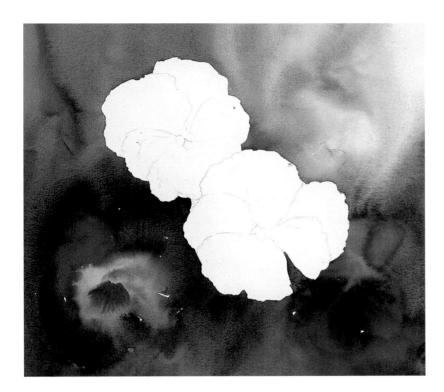

Ultramarine wet-into-wet to make two further pansies. While these were still damp, I added their darker markings with a mixture of French Ultramarine and a hint of Crimson Alizarin.

Second Stage

I started to fill in the white pansy shapes, using similar colours for both of them. These were Crimson Alizarin and Permanent Magenta with touches of a purple background mixture. Indian Yellow added a warm glow to some of the petals. I made the top flower darker from the start and made some of its petals stronger than the background to help them sit comfortably.

The flowers looked strange at this stage because they were both still too pale and needed more work. I decided to move into the background re-using the colour mixes that were still on my palette.

I painted around parts of the flower that I had sketched in at the start to make its pale yellow and pink tints evolve into a negative shape. I was careful to blend the new wash into the background with a clean wet brush to avoid a halo effect. I repeated this process on the lower pansies but used darker pigments.

I didn't work around the entire flowers but sharpened up here and there to give a 'lost and found' effect. Then I defined a couple of overlapping petals in the right-hand pansy and darkened the top petals to create a positive edge value.

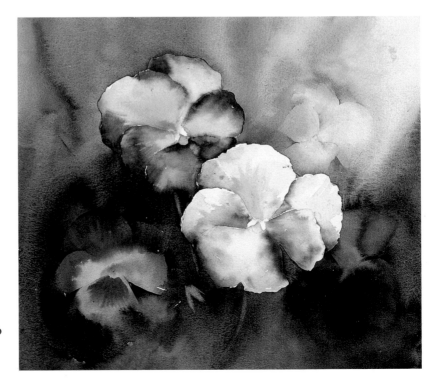

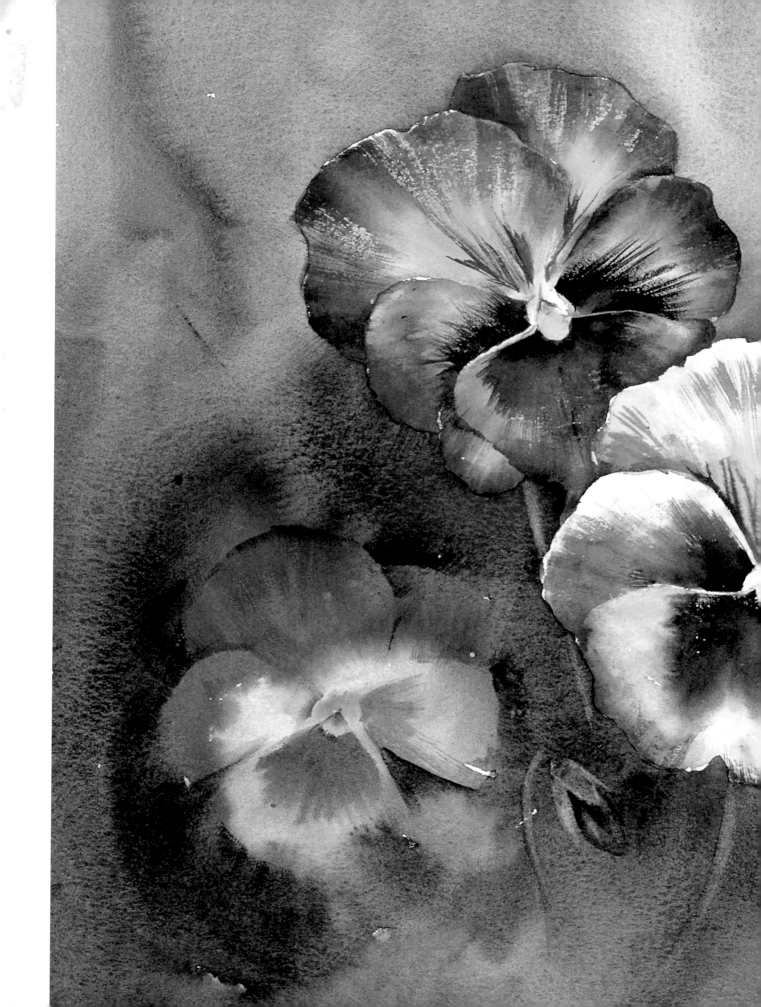

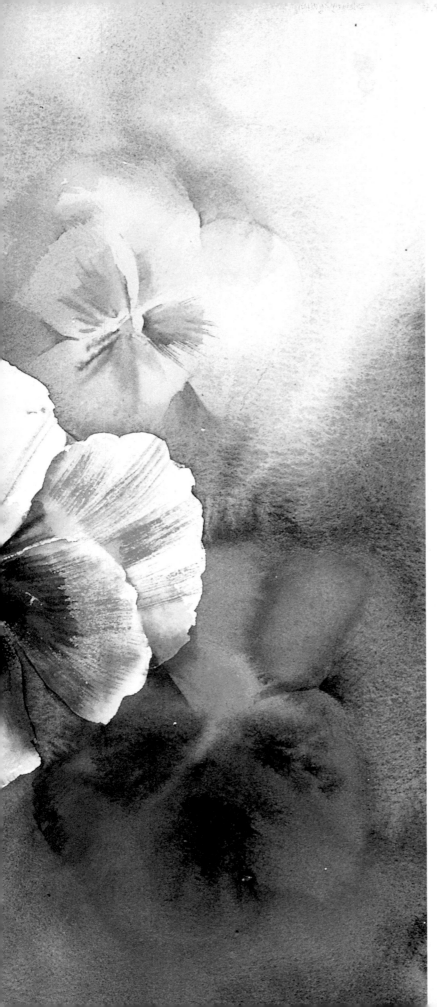

Finished Stage

In this final stage, I had to make the flowers balance more with the background. Pansies have opaque petals compared to other flowers and so more substantial paint work was required. I added another wash layer, eliminating most of the unpainted white paper on the top pansy, but leaving the lower pansy much paler.

While these washes were still damp, I added the characteristic dark markings, taking care to leave half-moons of white around the centre. Next, I dragged dryish paint over the top of the almost-dry washes to give the petals their velvety texture and veins. As a finishing touch, I emphasised the centres with a smudge of dark paint.

◀ **Pansies**
33 × 35 cm (13 × 14 in)

Winter Teazels

For this final demonstration, I set up a still life in my studio with spiky teazels and branches of scarlet hawthorn berries. I used these as a reference to help recreate the scene on paper as it had appeared outdoors. The teazels were almost silhouetted against a cool, pale sky. The smooth, shining dots of colour provided by the dangling haws made a good contrast to the prickly texture and decorative tendrils of the wintry seed heads.

▶ First stage

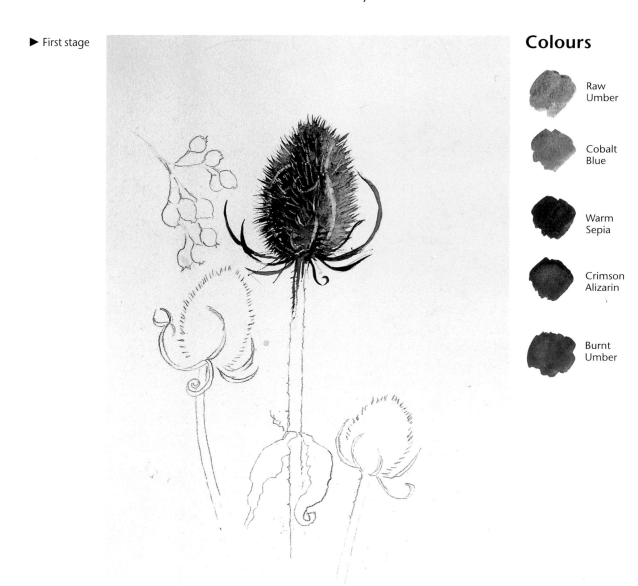

Colours

Raw Umber

Cobalt Blue

Warm Sepia

Crimson Alizarin

Burnt Umber

First Stage

I drew the outlines of the teazels and hawthorn to establish the main elements of my composition. I placed the largest teazel in a central position, high up the page to make it the principle focal point. Then I masked out the pale tendrils that curled within the dark bulk of the seed head to make it easier for me to paint the spiky textures.

Next, I mixed combinations of Raw Umber, Burnt Umber and Warm Sepia (diluting these less than usual to achieve a creamy texture). I filled in one teazel as a plain oval, blending from darker browns on the left side to light golden tones on the right to give a three-dimensional form.

While the paint was still wet, I dragged the edges out at right angles into prickles using a sharp point. I then scraped out some pale spikes from the damp, creamy paint of the teazel interior. (I would have lifted the spikes out with a small brush if the paint had been too dry to scrape.) Then I painted the dark tendrils in with a medium-sized brush.

Second Stage

I repeated the above process in the smaller left-hand teazel, and then removed the masking fluid from the pale tendrils.

The hawthorn berries were painted with Crimson Alizarin as simple ovals, leaving scraps of unpainted white paper to suggest shiny highlights. I painted a little Warm Sepia and some Cobalt Blue along one side of each berry to create tonal variation, then painted in the delicate stems with the wrong end of my brush.

I coloured in the masked tendrils, shading them to a darker tone where they disappeared underneath the teazels. Then I mixed a series of background tints using Cobalt Blue, Raw Umber and Burnt Umber diluted well to keep the mixes pale. I used these to paint variegated washes over the whole picture and around the teazels. The hawthorn was still damp in places and,

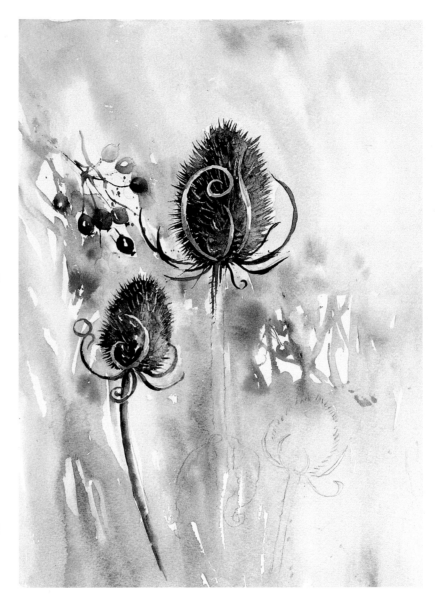

▲ Second stage

where my wash touched it, the moist paint bled into soft edges, partly merging them into the background. I decided to leave some of the berries crisp edged and so avoided these areas. This gave the effect of light peeping through branches. I then painted a few extra berries and twigs wet-into-wet, again leaving a few patches of white between some of the brushstrokes.

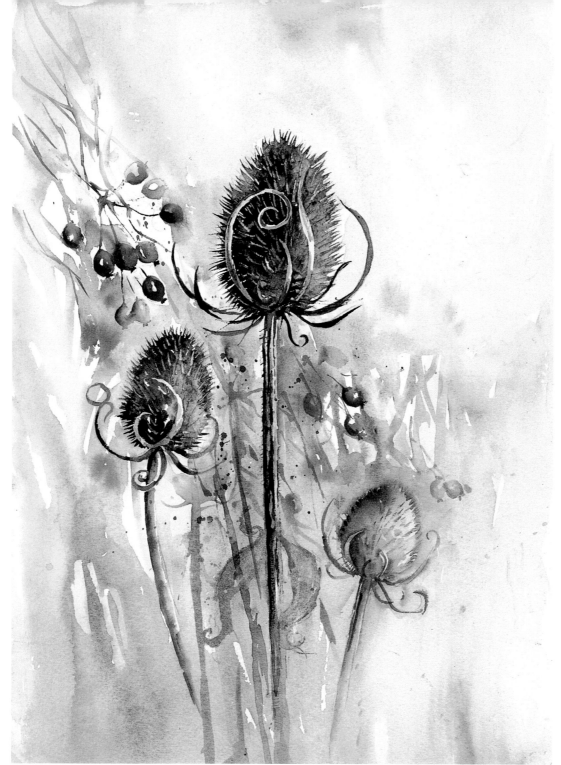

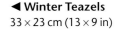

Finished Stage

Before the background washes had dried,
I began a third out-of-focus teazel by painting
its shadowy side wet-into-wet. When this was
dry, I blended the dark colour around the
other side to leave a pale negative edge. The
light tendril was also painted as a negative
shape by surrounding it with dark paint.

I used the same pigment for the teazel spikes,
stalk and tendrils. The stalk of the main teazel
was described with stripes of Warm Sepia, but
I left the existing background wash to suggest
highlights along the ridges. Finally, I firmed
up some of the background and berries and
included more stalks, branches, and some
twisting leaves to complete the design.